START TO PAINT
with Watercolours

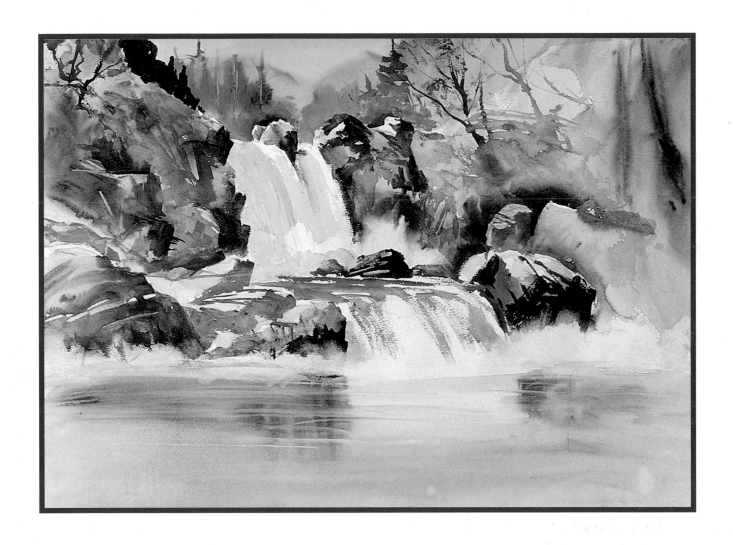

To my wife, Joy,
and all my family

START TO PAINT

with Watercolours

The techniques you need to create beautiful paintings

Arnold Lowrey

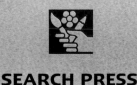

SEARCH PRESS

This edition first published 2016

Previously published 2002 as *Starting to Paint*

Search Press Limited
Wellwood, North Farm Road,
Tunbridge Wells, Kent TN2 3DR

Text copyright © Arnold Lowrey 2016

Photographs by Charlotte de la Bédoyère, Search Press Studios

Photographs and design copyright © Search Press Ltd. 2016

ISBN 978-1-78221-327-7

The Publishers and author can accept no responsibility for any consequences arising from the information, advice or instructions given in this publication.

Suppliers
If you have difficulty in obtaining any of the materials and equipment mentioned in this book, then please visit the Search Press website for details of suppliers: www.searchpress.com.

Always refer to your supplier's website or in store for the latest ranges.

Publishers' note

All the step-by-step photographs in this book feature the author, Arnold Lowrey, demonstrating his painting techniques. No models have been used.

There are references to sable and other animal hair brushes in this book. It is the publishers' custom to recommend synthetic materials as substitutes for animal products wherever possible. There is now a large range of brushes available made from artificial fibres, and they are satisfactory substitutes for those made from natural fibres.

Printed in Malaysia

Acknowledgements
I would like to take this opportunity to thank all my students for their continued support; Winsor and Newton for their encouragement; and John Dalton and Roz Dace of Search Press who, unerringly, were able to put this train back on track when, occasionally, it became derailed.

Page 1
Waterfall
Size: 685 x 495mm (27 x 19½in)

The focal point of this composition is the water cascading down between the rocks, so it is important to make this the lightest area of the painting. The dark tones used for the background sky and trees emphasise the brightness of the water at the top of the falls, as do those for the rocks on either side. The overall shapes of the foam at the bottom of each section of the falls must be made interesting and, invariably, you will have to make it so. The soft area of water in the foreground, with its horizontal and vertical strokes, contrasts with the drama defined by the diagonal strokes in the rest of the painting.

Pages 2/3
Church Rock, Broadhaven South
Size: 685 x 465mm (27 x 18¼in)

This is a quiet, peaceful painting, enhanced by using lots of vertical and horizontal strokes and by keeping the tonal range between light and middle tones. The sky and sea were both painted wet, starting with a wash of aureolin followed by washes of permanent rose and cobalt blue.

Opposite
Lakeside, Early Morning
Size: 685 x 470mm (27 x 18½in)

This picture was painted on 150gsm (70lb) grey pastel paper. This is so thin that it must be wetted and pre-stretched on a painting board to stop it cockling out of shape. When painting on tinted paper, you must use colours that are darker and stronger than those you would use on white paper. The light tones are created by mixing process white with the watercolours to make them opaque. The grey paper comes through everywhere, giving overall harmony to the painting.

CONTENTS

INTRODUCTION

So, you want to paint! And you have decided on watercolour. Well, the downside is that you have not picked the easiest medium. But you have picked a medium that creates the greatest light and luminosity, and the one which lends itself to small parcels of time. It also has other advantages, in that the equipment is small, less messy than most mediums and does not smell.

Having got that out of the way, let us explore your options to progress in this exciting medium. There are many ways of painting in watercolour and, in this book, I show you some of the important ones, in particular, the way I paint.

The most frequent questions I get asked are: 'What do I need?' 'What do I paint?' and 'How do I do that?' I hope to answer these points by taking you, step by step, through a series of projects. These include tips and techniques which, I hope, will help you produce effective watercolour paintings. These tips have been learned over the years, and were important to me when mastering this elusive subject. If only someone had shown me some of them when I started on this great journey.

Apart from dealing with the control of water, the use of tone and colour mixing, my most important tip is to fill your paintings with interesting shapes. To my mind, good shapes make great paintings, so you will find many references to this subject.

I was trained as an engineer and was always taught to find out how things worked. This is good advice, and I hope that my tips and techniques will show you the *mechanics of success*, stage by stage.

There are four great enquiries in life – philosophy, theology, science and art. You are about to embark on the last, a journey that will never end. It is not easy. If it were, no one would want to do it! So, pick up your brushes and start!

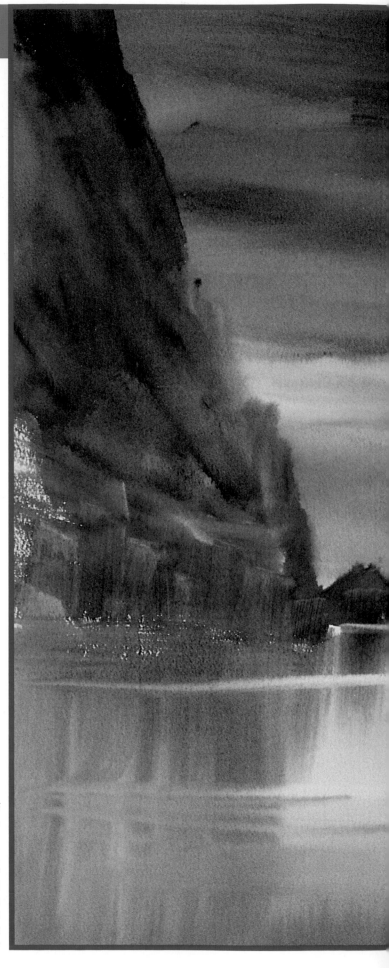

Boats at Sunset
Size: 635 x 495mm (25 x 19½in)

The sky colours in this dramatic sunset were painted wet in wet. Strong cadmium yellow and cadmium scarlet were laid in first, followed by washes of cobalt blue, ultramarine blue and mixes of ultramarine blue and cadmium scarlet. The land areas were painted with a thirsty brush and mixes of ultramarine blue and cadmium scarlet. The sea contains similar colours to the sky. Finally, the boats and their reflections were added, using mixes of ultramarine blue and cadmium scarlet.

MATERIALS

Art shops are like Aladdin's caves. There are so many types of paint, paper, brushes, etc., that the beginner can be totally overwhelmed. Even more confusing is that different manufacturers have different names for the same product. For example, a cool blue paint can be called Winsor blue, monastral blue, intense blue, phthalo blue and even Joe's blue. This does not help you, so here are a few guide lines to selecting equipment.

PAINTS

Watercolours are available as professional quality paints and in more affordable ranges. I recommend that you start with less expensive colours, then work up to the more costly, professional ranges later. Both qualities are available in tubes and pans. Tube colours produce effects that are extremely difficult, if not impossible, to create with the solid pan colours. However, pans have the advantage of being portable and convenient. Do not be tempted to buy cheap (unbranded) colours as these can turn out not to be the bargain you had hoped for!

I tend to use tubes of professional quality paints, but I often use the more affordable ranges for earth colours (see page 12 for my palette of colours).

BRUSHES

There is an enormous variety of brushes designed for the watercolourist. You may be tempted into buying lots of brushes for particular applications, but you can get by with just a few as each can do a variety of jobs. Someone once said: 'Get married to your brushes – know what they will and will not do!'

Sable hair brushes hold a great amount of water and also give it out at a controlled rate. They last a long time, but they are quite expensive.

Synthetic brushes are much cheaper than sable. They are very hard wearing, but do not give you as much control with the water.

Brushes with a mixture of synthetic and sable hair are my suggested compromise. They are reasonable both in price and in the application of colour.

Other natural hair brushes include pony and goat hair ones, which are useful for applying washes, and squirrel hair brushes (the softest of all) which are great for glazing over existing work.

Bristle brushes, usually used for painting with oils, are good for lifting out mistakes and softening edges. They also hold a lot of pigment with little water – a must for painting powerful strong colours.

I use a 25mm (1in) sable/nylon flat brush (also known as a one-stroke brush); a 13mm (½in) nylon flat brush with a scraper end; a no. 8 sable, round brush; and a no. 3 sable/nylon, rigger brush. I also use a 25mm (1in) bristle brush for spattering.

PALETTES

Again there is a wide range of palettes available, from large studio palettes to small portable ones, some with empty wells for filling with tube paints and others filled with pans.

Apart from the spaces for your colours, watercolour palettes should have areas for mixing paint with controlled amounts of water and some wells for mixing washes. One of the problems of using tube paints is that unused paint dries when not in use. Some palettes have a lid which, in combination with a damp sponge, helps to keep unused paints moist.

I use two palettes. My studio palette, which I designed myself, has open-ended paint containers, a slightly angled, flat mixing area, a couple of wells for wet washes and a lid which locates under the palette to catch excess water. When not in use, the lid, together with a damp sponge placed on the mixing area, keeps the paints moist. My other one, a small enamelled-brass, portable palette for tube paints, is a joy to use in the field.

WATERCOLOUR PAPER

Do use proper watercolour paper. Do not try and save money by painting on, say, cartridge paper; you will never get a worthwhile result. Watercolour paper is made from either cotton (often called rag paper) or wood pulp, and is available in different thicknesses (or weights), surface textures and sizes. Most papers are treated with size which helps keep paint pigments on the surface.

Cotton paper produces glorious washes of colour that are so addictive in this medium. Wood pulp paper is less expensive but, to me, it is more absorbent than cotton paper. However, I suggest that beginners use wood pulp paper, as you can sponge out any mistakes more easily. Remember, the man who never made a mistake, never made anything! So, practise your techniques, first on wood pulp papers, then work up to the cotton ones. Eventually, you will choose your own personal favourites.

Sheet size

Although sheet sizes are now measured in metric units, the old imperial names are still used for some sizes. Full sheets of watercolour paper are called **imperial** and measure 760 x 560mm (30 x 22in), but you can also obtain larger sizes such as **elephant** and **double elephant**, or 10m (33ft) length rolls. Naturally, these sizes are for special work.

You can also buy smaller sizes of paper which are usually supplied as ring-bound pads or blocks. The latter consist of several sheets of paper glued together around their edges to form a solid block. This is ideal to paint on, and a small gap in the glue is provided for separating the sheets with a paper knife. So, you can either buy the full sheets and cut them to the size you want, or buy the pads or blocks for convenience.

Thickness

The thickness of paper is measured in grams per square metre (gsm), but you can still find some marked in pounds (lb). Thick paper, although more expensive, is less likely to bend out of shape when wet, and will hold more water. A good weight to start with is 300gsm (140lb).

Surface textures

There are three basic surface textures available: hot pressed (HP) papers (also known as fine or fino papers) have a smooth finish; cold pressed (NOT – meaning not hot pressed) papers have a medium grade finish; and rough, which speaks for itself. Below are samples of these three types of surface finish, each painted with similar brush strokes.

Hot pressed (fine or fino) paper

Cold pressed (NOT) paper

Rough paper

SUPPORTS

Single sheets of watercolour paper must be supported while you are painting. Any stiff board will do, but I use a piece of plastic-coated hardboard and I fix my paper with spring clips in the corners.

EASELS

Watercolours should be painted at an angle so that spare water flows downwards – puddles can form on flat paper. If you are painting indoors, a table with something underneath to tilt your paper support at, say, 30 degrees will prove adequate. Outdoors, especially when painting on large sheets of paper, an easel is essential. Once again, the choice is quite vast and ranges from small table easels to large

freestanding ones. You can also buy box easels which, as the name implies, includes a box for holding your equipment and paper; these are extremely firm structures but can be very heavy when full of kit!

For the beginner, I would suggest an aluminium or steel telescopic easel; these are inexpensive, robust, relatively lightweight and easy to assemble. Some wooden easels can be awkward to assemble and, if they get wet, the wood can expand and make them difficult to dismantle.

OTHER EQUIPMENT

I use soft **4B pencils** and **graphite sticks** for sketching and for drawing the outlines of a composition on watercolour paper.

A kneadable **putty eraser** is useful for removing unwanted marks from watercolour paper; it is extremely soft, absorbs the graphite into itself and does not damage the paper.

A **razor blade** is extremely useful. Use the flat of the blade for scraping shapes out of wet paint and its tip for scratching highlights out of dry paint.

Paper towel is ideal for lifting out colour, drying brushes and mopping up spills. Small pieces of **sponge** are also useful for lifting out colour.

A roll of **masking tape** is always useful, but I tend to limit its use to creating sharp, straight horizons.

Process white is not a true watercolour but it is a very opaque white which is ideal for creating smoke, snowflakes and spray. It can also be mixed with watercolours to make opaque tones.

A **bristle brush** is useful for spattering tiny spots of spray or snow.

A **hairdryer** and **water sprayer** can prove useful additions to your workbox.

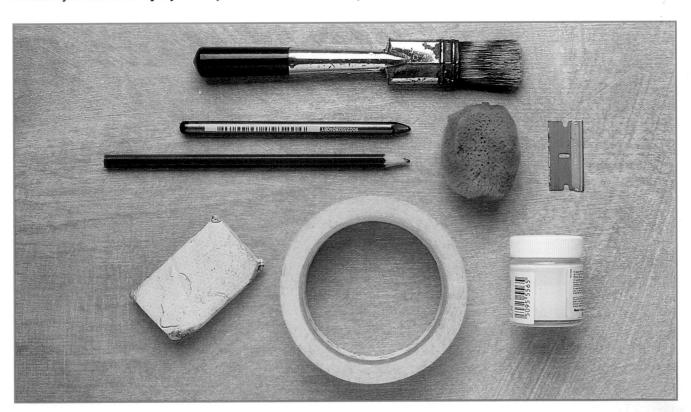

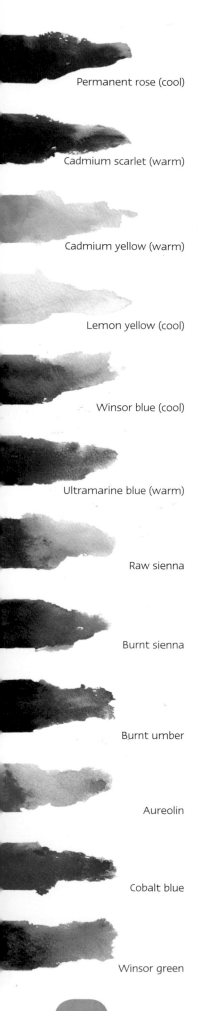

Permanent rose (cool)

Cadmium scarlet (warm)

Cadmium yellow (warm)

Lemon yellow (cool)

Winsor blue (cool)

Ultramarine blue (warm)

Raw sienna

Burnt sienna

Burnt umber

Aureolin

Cobalt blue

Winsor green

BASIC TECHNIQUES

In this chapter, I talk about my palette of colours, how I mix colours, and the different brush strokes and other techniques that I use when painting.

MY COLOUR PALETTE

The twelve colours shown on this page are always in my palette. It consists of two of each primary colour (red, yellow and blue), three earth colours, and three special colours (a yellow, blue and green). It is a range of colours that I have developed over the years; some of my original palette of colours remain, others have been replaced and new colours added.

COLOUR MIXING

It is important to understand the basics of colour mixing or you will never get beautiful colours in your pictures. As children, we were taught how to mix red, yellow and blue (the primary colours) to create orange, green and purple (the secondary colours). Beautiful, clean secondary colours can only be created from a mix of two primary colours however and, unfortunately, there are no perfect primary colours available. Cool reds such as permanent rose and alizarin crimson contain touches of blue, whereas warm cadmium scarlet and cadmium red contain touches of yellow. Similarly, yellows can have touches of red or blue, and blues can have touches of red or yellow.

To overcome this problem, my colour wheel, shown opposite, has two tones of each primary colour. Clean, bright secondary colours are produced by selecting two primaries that only contain touches of each other. Selecting two colours that contain a third primary colour will give dirty or greyed colours. However, just because a colour is described as dirty, does not mean that you cannot use it in your painting. The dirty green shown in the middle of the colour wheel might well appear in oak leaves, and earth colours (browns) are also dirty colours. Paler tones of all colours can be obtained by adding more water.

Red, yellow and blue mixed together make black. Blacks can be mixed as cool or warm colours depending on the proportions of the three primaries. They can be thinned with water to greys, but more useful greys can be mixed in other ways (see page 14).

You may think it wasteful to use some of your valuable watercolour paper practising colour mixes. It is better to make mistakes on small pieces of paper, and learn from them, rather than to ruin a painting on a large sheet.

Clean purples mixed with
cool blue and cool red

Warm blue

Cool red

Dirty purples mixed with
warm blue and warm red

Cool blue

Warm red

Dirty greens mixed with
warm blue and warm yellow

Dirty oranges mixed with
cool red and cool yellow

Clean greens mixed with
cool blue and cool yellow

Clean oranges mixed with
warm red and warm yellow

Cool yellow

Warm yellow

Greens

Green is the colour used most badly by beginners. Quite a variety of ready-mixed greens is available to the artist, but I like to mix my own. Below I have included some greens that can be mixed from the two blues and yellows in my palette.

I do have the ready-mixed Winsor green in my palette, but I normally mix this with other colours, such as burnt umber, to make different shades.

Burnt umber and Winsor green

Winsor blue and cadmium yellow

Ultramarine blue and cadmium yellow

Winsor blue and lemon yellow

Ultramarine blue and lemon yellow

Blacks and greys

The earth colours in my palette are useful short-cuts for mixing natural blacks and greys. A mixture of burnt umber and ultramarine blue, for example, gives a strong black and some good greys. Burnt sienna and Winsor blue will also produce a good black and some slightly green greys.

For a really transparent grey, try mixing Winsor green and permanent rose.

Winsor blue and burnt sienna

Winsor green and permanent rose

Burnt umber and ultramarine blue

BRUSH STROKES

You do not have to own a lot of brushes to mark different marks. This is evident from all the shapes shown here, which were made with a 25mm (1in) flat brush, a no. 8 round brush and a no. 3 rigger brush.

Hold the chisel end of a flat brush at 90 degrees to the paper to make these marks.

Use the full width of a flat brush to paint areas such as this roof, working each stroke from the ridge down to the gutter line.

Hold a flat brush parallel to the paper, then drag it across the paper to create this sparkled mark.

Use the corner of a flat brush, held level with the paper, to make these marks.

Twist a flat brush as you draw it across the paper to make these marks.

Hold a flat brush at about 45 degrees to the paper, then, without lifting it off the paper, wiggle the brush up and down as you move across the paper.

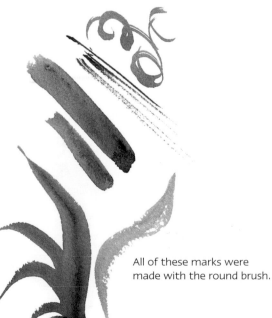

The rigger brush is designed to make continuous, long, thin lines. However, if the brush is pushed down to the hilt, it will produce thicker lines which can then be made thinner as the brush is lifted off the paper.

All of these marks were made with the round brush.

PAINTING TECHNIQUES

On these pages I show you some painting techniques that I find most useful. They are quite easy to master, but it is worth experimenting with them on scraps of watercolour paper before using them in a painting. I have cross-referenced each technique to its application in one or other of the projects.

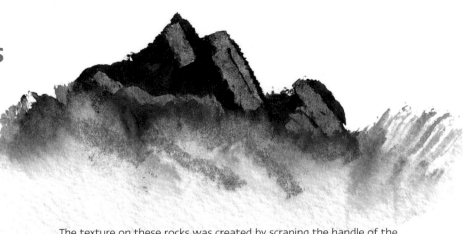

The texture on these rocks was created by scraping the handle of the scraper brush through wet paint. The foamy water at the base of the rocks is the result of lifting out colour with a sponge.

Single-colour wash painted onto wet paper. A plain wash can be worked by applying the same mix all over the wet area. However, for skies it is better to create a graduated wash by gradually diluting the mix as you work down the paper. See page 39.

You can create some fantastic effects with this mingling (wet in wet) technique, but you must work quickly. Mix each colour to the correct tone in a flat palette, wring out the brush, pass it just once through the wash, then apply it to the wet paper. See page 80.

Lifting out colour with a sponge is an ideal technique for creating spray.

Lifting it out with a piece of paper towel is good for hard-edged clouds (see page 49)

Using a thirsty brush to lift out colour is useful for more defined shapes, such as the reflections of buildings (see page 52).

For this dry-on-dry technique, neat colour is applied with a damp brush held quite flat. Useful on Not and rough papers for creating sparkle on water and texture in foliage. See page 43.

Glazing, or laying one colour over another that has been allowed to dry, shows how the transparency of watercolours can be used to create subtle changes in colour. See page 42.

This is a dry-in-wet technique, where a thirsty brush loaded with colour is applied to a wet background. See page 50.

Use the flat of a razor blade to scrape into wet paint. A good technique for trees, as shown here, and for rocks (see page 59).

These marks were made by scraping into wet paint with the handle of the scraper brush. Varying the angle of the scraper to the paper will change the width of the marks. A good technique for drawing in spindly tree trunks (see page 40).

These marks, created by adding water to half dry paint, are known as backruns or cauliflowers. Unintentional backruns can ruin a painting, but the technique is useful for denoting mistiness in distant trees (see page 50).

STARTING TO PAINT

When I raised the question about what to paint with my first teacher, he said: 'Whatever you want to paint, I will help you to paint it better!' Although it is important to try painting different subjects, when you are starting out, choose one that interests you and this interest will be reflected in your efforts. If you like boats, paint them, but do not pick a difficult three-masted schooner to begin with.

We are all very selective in what we want to see. A group of people looking at the same scene will all have different feelings about it; some may love it, others could be quite put off. The more you paint, the more you realise how complex

and interesting this subject is. So do not rush in with the brush; take time to absorb the scene, then think about painting what really interests you about it.

Beginners find painting on site a frightening thought, so why not start by working from photographs as a reference source and extract the relevant information to build your painting.

It is a good idea to work from a selection of photographs of the same subject. These could include a panorama of the whole scene and some closer images as shown below.

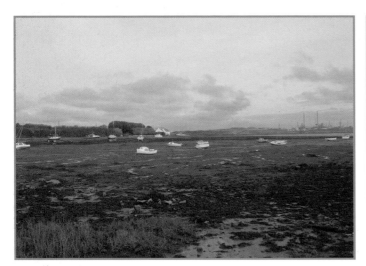
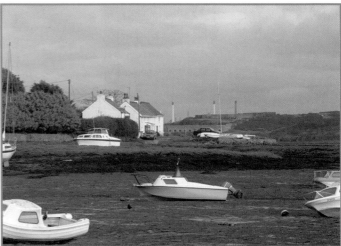

These two photographs were taken from the same viewpoint. Wide-angle views do not necessarily make good compositions, but they do help to define the mood of the subject. The second image, taken with my zoom lens, shows much more detail and the variety of interesting shapes makes it a reasonable composition.

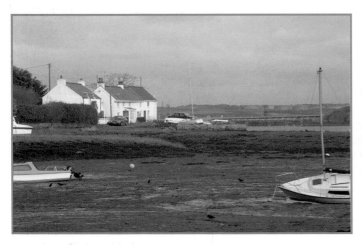
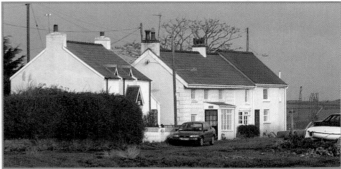

Again, these two images were photographed from the same viewpoint. For these images, I moved my viewpoint further to the right so that I could see more of the front of the cottages.

You do not have to paint everything you can see. Select a part of the scene that has a point of interest (focal point) which attracts you. The two painting shown here (and enlarged on page 23), each of which reflects a completely different mood, were painted from the same reference photograph.

I talk about mood on the following pages, but here are a few rules to bear in mind about composition: never set your horizon halfway down the painting; place the focal point slightly off centre; and choose interesting shapes – remember, good shapes make great pictures.

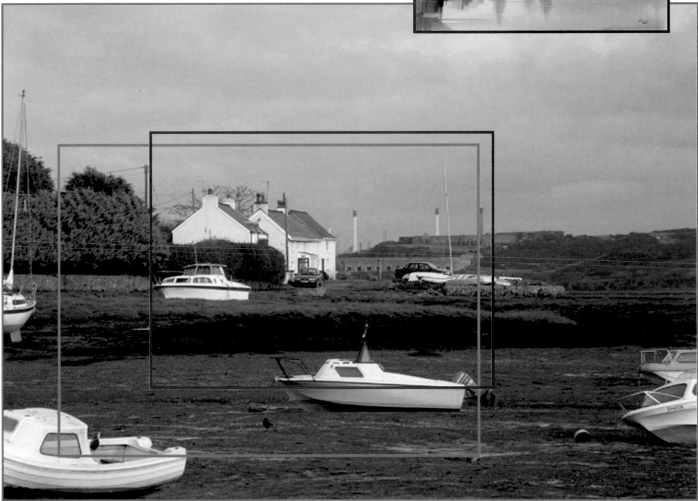

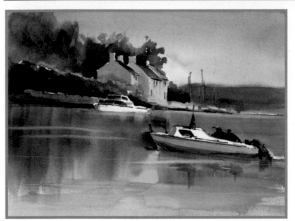

The two finished paintings shown here were taken from this photograph.

For the full-colour painting above, I used the part of the photograph bordered in grey. Notice that I have removed all the boats and cars in the foreground, the large building behind the cottages and the two large chimneys in the distance. I have also painted the scene at high tide to allow me to have some good reflections in the water.

The monochrome, painted in burnt umber, shows how easy it is to make a completely different composition from the same scene. For this painting I used the part of the photograph bordered in orange. Again I removed all items that could take the eye from the focal point. Notice that at high tide the foreground boat is floating rather than resting on the sand, making it nearer to the distant boat.

When you have decided on a composition for your painting, you then have to consider how to paint it. Always remember that your painting, unlike a photograph, is your interpretation of the scene – other viewers of your finished painting will not have seen what you 'saw', so you can change anything. For the following exercises, which show different interpretations of the same scene, I chose this photograph, as it was the cottages that first attracted me.

You can affect the mood of a painting by varying one or more of the following: the tonal structure (the relationship between lights, mid-tones and darks); the temperature range of the colours (warm or cool); the direction of the light source and shadows; the time of day (the tone of the shadows); and edge textures.

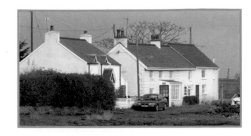

I used this photograph for the following exercises in tone, shadows, edge structures and colour temperature.

TONAL STRUCTURE

Before starting to paint a subject, it is always worthwhile making a tonal sketch of the scene and look at the relationship between the light, dark and mid-tone areas. Lots of similar tones next to each other will produce flat uninteresting pictures. If your first tonal sketch of what you see appears that way, try working it again setting light and dark areas against mid-tone ones.

These three tonal sketches of the same scene each have different relationships between the light, mid-tone and dark areas. See how they affect the mood of the picture.

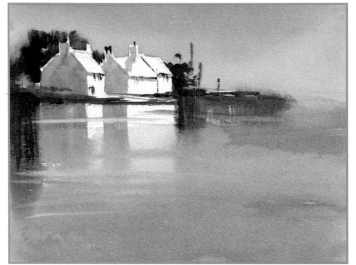

Mid-tones dominate this version of the scene, but they help emphasise the light areas of the cottages, (the focal point), which are also brought into relief by the dark areas on either side. The combined area of the light and dark tones makes an interesting shape.

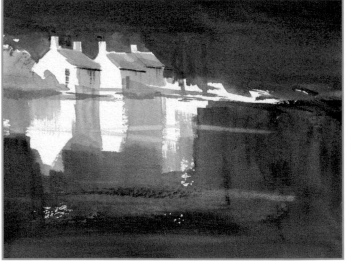

In this sketch, dark tones predominate, but the eye is still drawn to the light and mid tones used for the cottages. Note the different shapes created by the reflections.

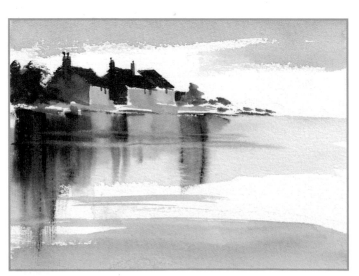

Here, the focal point consists of mid- and dark tones which are brought to prominence by the light tones in the sky behind the cottages and those across the foreground stretch of water.

COLOUR TEMPERATURE

The range of colours used for a painting also has a profound effect on the perception of the viewer as to its mood. Note the difference between these two colour sketches – one is full of warm and inviting colours, the other cool and aloof ones. Both images, which are based on the first of my tonal sketches, still look rather flat. This problem could be overcome by introducing touches of cool colours to the yellow sketch and touches of warm colours to the blue one (see the sketches below, and the warm red roof in the snowscene on pages 86–87).

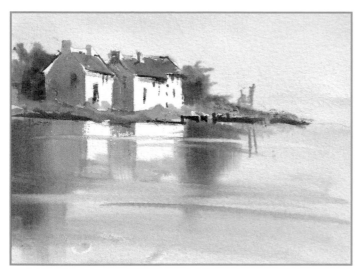

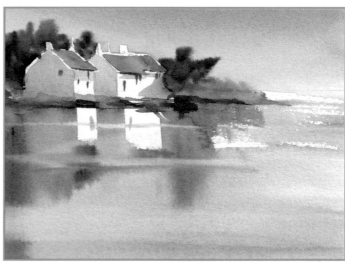

DIRECTION OF THE LIGHT SOURCE

You can place the sun wherever you want it to be, but remember to make all the shadows consistent with the chosen position, especially if you are working from a photograph. Also remember that, if you are painting outside, the sun and shadows are moving all the time.

In the sketch, below left, the light is coming from the right-hand side, lighting up the front walls and roofs of the cottages. In the sketch below right, the light is from the left-hand side, lighting up the gable ends of the cottages. Note the use of cast shadows on the nearest cottage to create interesting shapes.

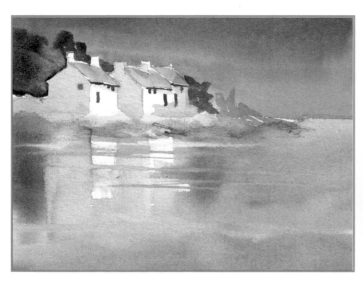

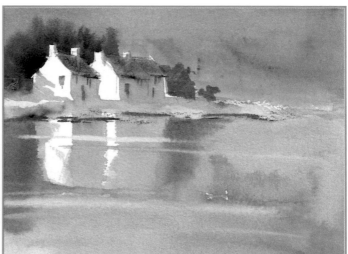

TIME OF DAY

The time of day has a great effect on the tone and shape of shadows. Contrary to common belief, the longest and darkest shadows appear early in the morning or late in the afternoon. At midday, when the sun is high in the sky, the shadows are paler because they are affected by glare reflected from the surfaces around them. You can use long cast shadows to break up large shapes into smaller, more interesting ones.

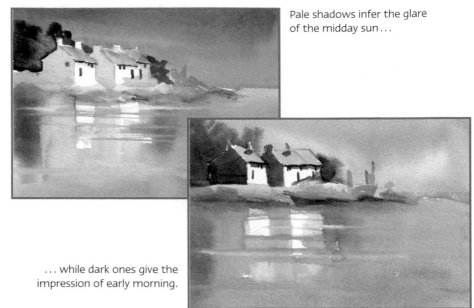

Pale shadows infer the glare of the midday sun...

... while dark ones give the impression of early morning.

EDGE TEXTURE

Varying the edge texture applied to the shapes in a painting can have a dramatic effect on the finished result. These two sketches illustrate this point – the small one is full of hard edges, while those in the other one vary from hard to soft to rough. Which one do you prefer?

The use of hard edges round every shape gives the impression that all the objects have been cut out of separate pieces of paper and stuck on the painting.

Varying the edge texture of shapes in a painting from hard to soft to rough, a technique sometimes referred to as lost and found, stitches each shape into the composition and makes it part of the whole.

CHECK LIST

I always fill in this check list before I start a painting. It is well worth the effort of planning how you intend to paint a scene, and a simple record of your decisions can be referred to as you paint.

1. What is my focal point?_____
2. Where shall I place the focal point?
 (top or bottom, left or right)_____
3. How large shall I make the focal point?_____
4. Is the tonal structure interesting?_____
5. Is it colour temperature warm or cool?_____
6. Are the shapes interesting?_____
7. Where is the light source?_____
8. Am I varying the edges of my shapes?_____
9. Have I enough paint in my palette?_____

This monochrome painting is also taken from the photographs on page 18. In this composition, the focal point is the more distant boat rather than the cottages. I washed a tone over the cottages to push them into the background, and left the hull of the boat white to attract the eye. The white area on the top of the boat in the foreground catches the eye first, but its shape does lead the eye to the other boat.

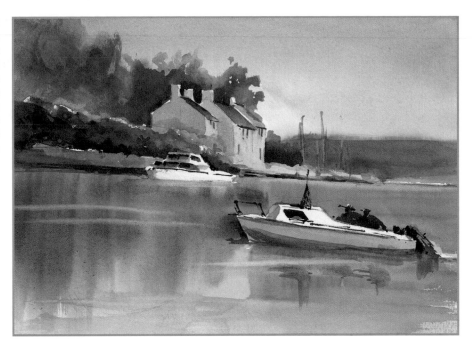

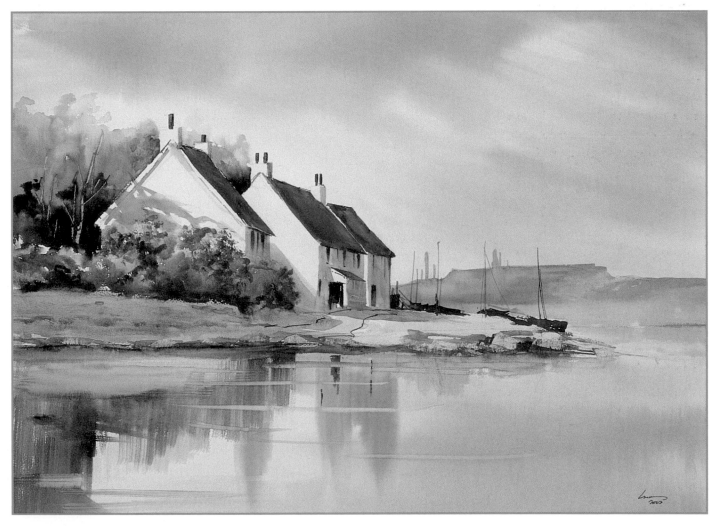

A finished painting taken from the reference photograph shown on page 19. Can you see which parts of the original photograph I selected and what tones, shadows, light source and colour temperature I used to give the painting my personal view?

ELEMENTS OF A PAINTING

There are lots of different elements that can be included in a painting, but here I concentrate on those that always seem to cause problems for the beginner: skies, trees, figures, buildings, water, rocks, hills and mountains.

SKIES

The type of sky most frequently seen at exhibitions has three or four, equally sized cotton wool balls sitting in a flat blue sky. This might be all right for some, but you should try to get away from this stereotype and start painting some real ones. The sky changes every minute, so it is impossible to paint a true image of what you see. When you see a sky you like, make notes about the time of day, where the sun is, the colours in the sky, how the light affects the colours on the ground, and the shapes cast by any shadows.

If your painting is mainly about the sky then you can paint lots of interesting cloud shapes. On the other hand, if it is about the land, choose a simple sky as lots of sky detail will take the eye away from your focal point.

It is important to remember that clouds, as with other more solid objects, should reflect the perspective of a composition. Those further away from you should always be smaller and closer together than those nearby. Whatever the type, it is vital to have interesting cloud shapes. If these are predictable and boring, so will be your painting. There are so many types of sky that it is impossible to illustrate them all, but here are a few different types that you might try. Other types of sky can be seen in the finished paintings included throughout this book.

A clear sky is never the same colour all over. This midday sky, for example, has a pale, warm yellowy base which, higher up the paper, changes to a pale, cool blue and onto a darker blue at the top. I started this painting by wetting the whole of the sky area. Working quickly, I laid in a wash of raw sienna along the horizon, weakening it as I worked upwards. Then, starting at the top, I followed up with a wash of ultramarine blue, gradually weakening it as I worked downwards.

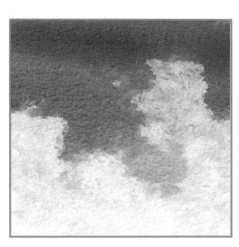
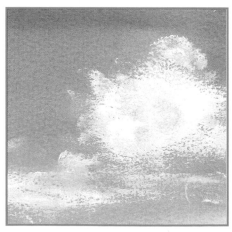

Cloud patterns vary from the large billowy cumulus to the wispy cirrus. Whatever the type, try to make your cloud shapes interesting. If they are predictable and boring, your painting will be the same. These two examples of billowing clouds were created using two different techniques. For the left-hand one, I used a paper towel to lift the clouds out of a wet blue sky (a damp sponge will produce softer edges). The clouds in the right-hand example were produced by applying process white with a circular motion of a finger on a dry background.

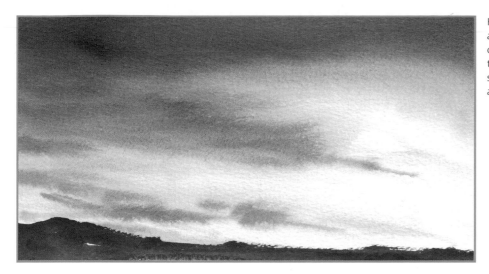

Here, the clouds are darker than the sky, but, as they are pale and soft, they give a feeling of peace. Using a thirsty brush, I picked up the colour from the palette with one single stroke – to limit the water content – and applied this to the wet sky area.

The clouds in this sky were applied in the much same way as described above, but the stronger tones produce an angry looking sky.

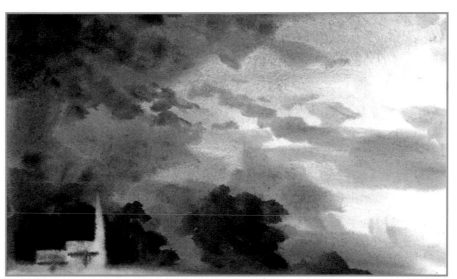

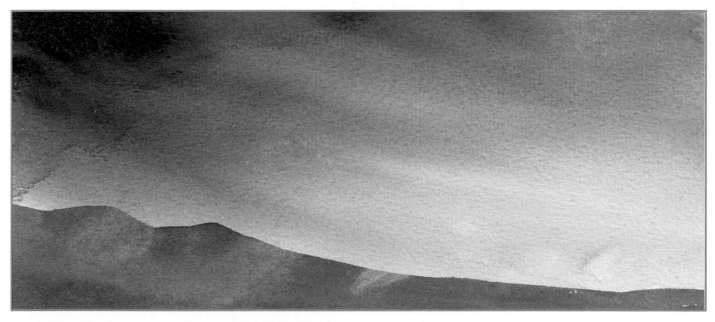

This sky shows distant rain clouds and was produced by first painting the sky without clouds and letting it dry. It was then carefully re-wetted and some dark clouds painted in with a thirsty brush. Quickly, before these were dry, I tipped the paper vertical and tilted it sideways (at the angle of the falling rain), then used a water sprayer to apply a mist over the sky. When the 'rain' started to pour from the dark clouds, I dried it quickly with a hairdryer.

TREES

Trees are a growing problem! We all have childhood memories of the things around us, but the problems come when we recall what we thought we saw and try to draw them. Trees are no exception; consequently, they are usually painted with the roots too big and the trunks too fat. When we were children, we were much smaller and our perception of trees was that the roots were big and the trunks huge!

Let's look at the way trees grow. I know that there are lots of different shapes of trees, but, for this particular exercise, there are two groups: deciduous (those that lose their leaves every year) and evergreens.

Deciduous trees

When painting a deciduous tree, look for the overall silhouette formed. If it has good shapes, then you have an interesting tree.

When the trees are covered in leaves, do not try to paint every leaf! Paint clusters of leaves, then put in the bits of branch that show between them. Look at the way the light falls on the tree and remember to paint in the shadows – the formed shadows on the parts of the trunk and foliage facing away from the light, and those cast by the tree on surrounding objects.

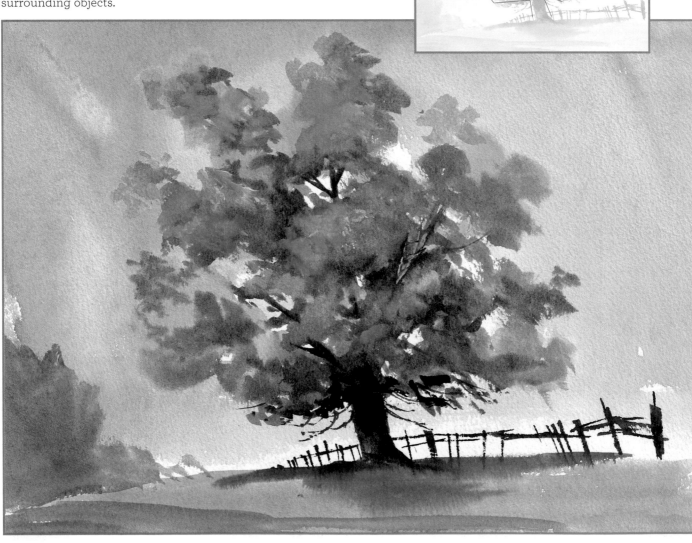

Although there are exceptions, the trunks of most trees in this group do not grow straight. When a young trunk grows up, it sprouts a branch. As this branch increases in size, and gets heavier, the main trunk starts to bend in the opposite direction to balance the weight. The same thing happens as each new branch is formed; the trunk usually ends up looking straight, but will have lots of kinks in it. Trees will sway in the wind, and those in exposed very windy areas can have a curved trunk, but these forces are counterbalanced by the strength of the root system.

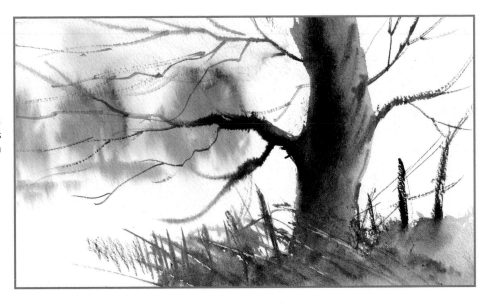

Evergreen trees

I use the term evergreen in a very loose way to denote trees, such as spruce and Douglas fir, with narrow and straight trunks.

Interesting silhouettes of single trees in this group are not easy to find, but look out for them. However, groups of these trees do make good shapes. Overlap them, include different sizes and heights, vary the angle of the trunks and the spacing between them, and you will have good shapes for your painting.

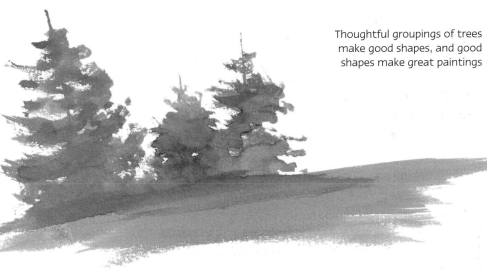

Thoughtful groupings of trees make good shapes, and good shapes make great paintings

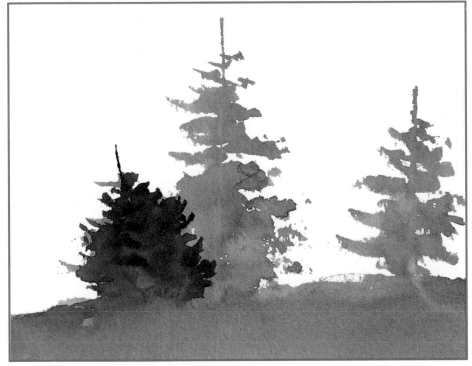

Distant trees should be treated as simple silhouettes, Paint them using the technique of aerial perspective (see also page 34). Make the distant ones soft edged and pale bluey-green. As you come forward, gradually make the edges sharper, and their colours darker and warmer.

27

WATER

Water is, on the face of it, a difficult thing to achieve in painting. This is because you want to paint every ripple on its surface, every wave and every drop of spray. The secret is to try to simplify things into interesting shapes and edge textures.

I have a great love of water scenes, especially seascapes, and I often spend hours watching the movement of the sea. I study the swells out at sea and how they develop into waves. Then, when the waves break on the sand and rocks, I look at the shapes of the resulting foam and spray patterns. You must do this too – not just for water scenes but for every subject you paint. Get to know your subject and you will be able to paint with confidence. Here are a few small watercolour sketches showing different types of water.

My tip for creating the impression of movement is to make the moving object out of focus.

For this sketch of waves lapping against a rocky outcrop I painted in the dark rocks, leaving rough shapes of the water along the bottom edges. These shapes were then enhanced with sponging while the paint was wet. When the paint was dry, I used the corner of a razor blade to scratch out the small splashes of spray.

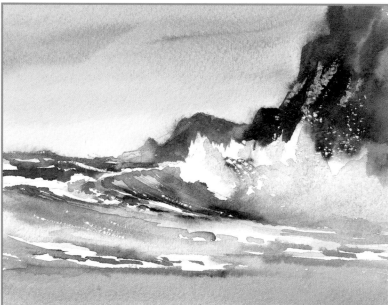

The wave crashing against the rocks comes to life if the overall shape of the white foam is interesting to the eye. Movement is enhanced by the variety of textures and the use of soft, sharp and rough edges.

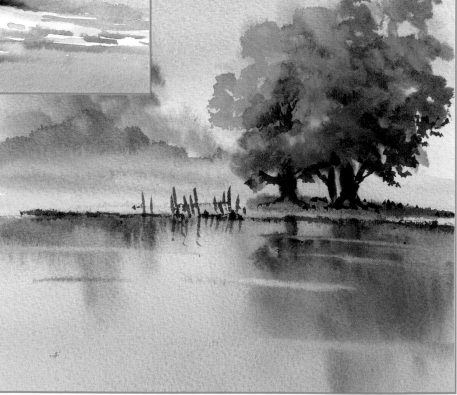

Soft, out-of-focus reflections on smooth surfaces of ponds, lakes and rivers are obtained by first wetting the water area, then quickly dragging the reflected colours into this wet area with a thirsty brush.

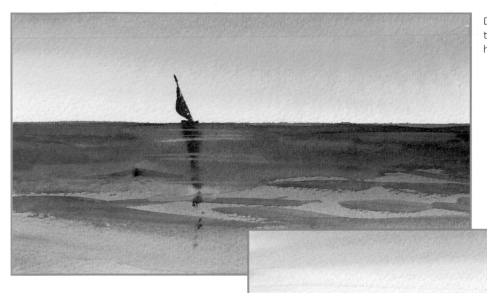

Depending on the position of the sun, the sea sometimes appears darker on the horizon than in the foreground...

... at other times, it is so pale that it is difficult to see where the sea and sky meet.

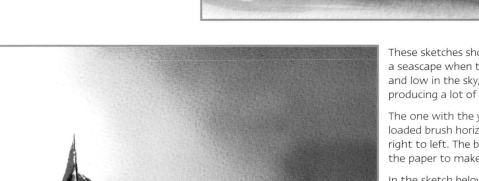

These sketches show two different ways of painting a seascape when the sun is directly in front of you and low in the sky, backlighting the subject and producing a lot of glare on the surface.

The one with the yacht was painted by dragging a loaded brush horizontally across the sea area, from right to left. The brush was held almost flat against the paper to make the sparkles.

In the sketch below, I painted all the sea with dark tones of blue, then, when this was dry, I used process white to paint the highlights on the surface of the water.

FIGURES

Incorrectly drawn figures can spoil a painting, and I see the little man opposite in many exhibitions – the legs and arms appear to be connected to the centre of the body, and the head is always too big. In reality, arms and legs are connected to the sides of the body, and only small children have large heads in relation to their height. Our bodies grows faster than our heads; whereas a baby might be four heads high, an adult could be eight heads high.

One of the reasons heads in paintings are too big is because they are often painted first. If you do this, you are committed to a body at least eight times as long and, as there is often not enough room, the figure ends up looking completely wrong. The answer is to paint the bodies first, then add a head, smaller than you would normally do, and gradually increase its size until it is just right. Do not include lots of detail. Very often, hands and feet are not necessary, and you should certainly not include buttons on a shirt!

On these pages I illustrate some important points that you should consider when putting figures in a landscape. Remember that details will not necessarily make your paintings realistic. Realism comes from good gestures, interesting shapes and the correct size of figures relative to the perspective of a composition.

Wherever possible, overlap figures. This will improve the overall shape of the silhouette.

Give your figures a realistic shape. Rarely do we stand upright with our weight shared equally on both legs. When we move, we shift our weight from side to side, and you should try to capture this movement. Lock the figure to the ground with a shadow and the overall silhouette will be greatly enhanced.

Size the figures in proportion to the perspective of the composition. For example, in this worms-eye view, with an eyeline at ground level, all the feet are on the eyeline but the figures are larger as they get closer.

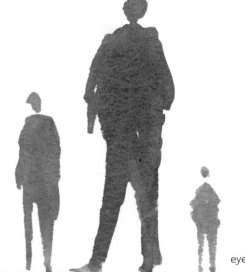

eyeline

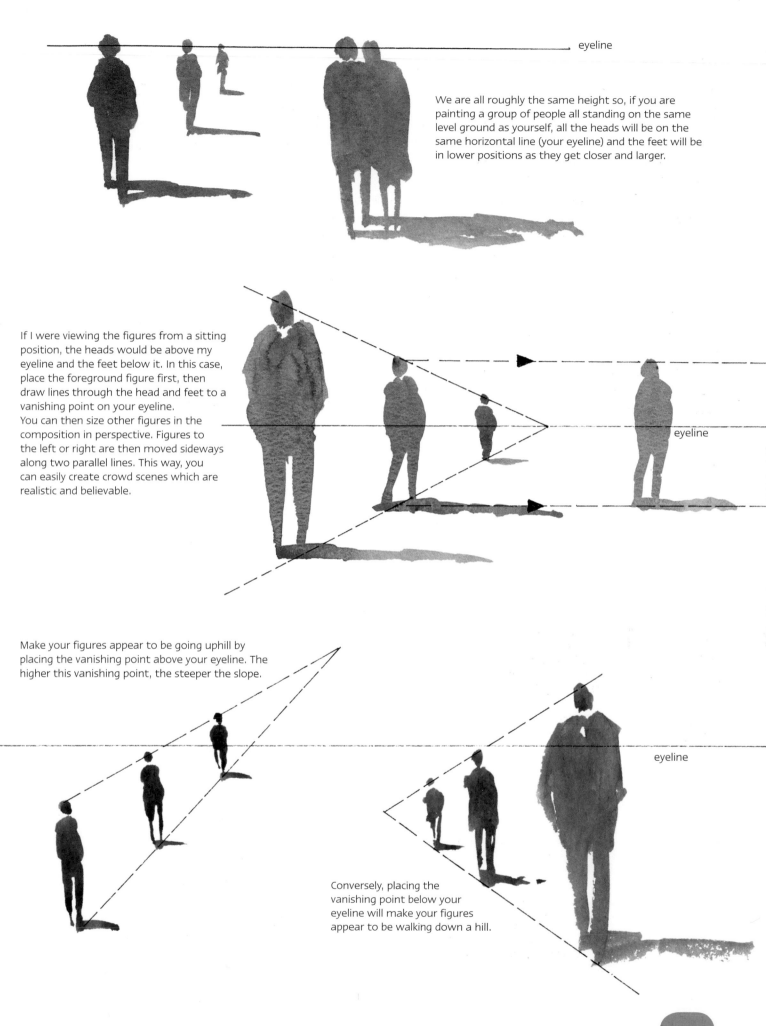

eyeline

We are all roughly the same height so, if you are painting a group of people all standing on the same level ground as yourself, all the heads will be on the same horizontal line (your eyeline) and the feet will be in lower positions as they get closer and larger.

If I were viewing the figures from a sitting position, the heads would be above my eyeline and the feet below it. In this case, place the foreground figure first, then draw lines through the head and feet to a vanishing point on your eyeline.
You can then size other figures in the composition in perspective. Figures to the left or right are then moved sideways along two parallel lines. This way, you can easily create crowd scenes which are realistic and believable.

eyeline

Make your figures appear to be going uphill by placing the vanishing point above your eyeline. The higher this vanishing point, the steeper the slope.

eyeline

Conversely, placing the vanishing point below your eyeline will make your figures appear to be walking down a hill.

31

BUILDINGS

If you want to paint buildings you come up against perspective. This subject is a great turn-off for many students, and I never tell mine when I intend to cover it! So, rather than use the word perspective, let us talk about getting depth into the picture, and making objects sit correctly in their surroundings. This is a large subject – too big to be fully covered in this book – but there are a few important principles that you should understand.

First, it is important to establish your eyeline; an imaginary horizontal line, parallel to your eyes. You look up at objects above the eyeline, and down at those below it. For instance, when you stand close to a house, the roof is above your eyeline and the doorstep below it. On level ground, your eyeline will be level with a point three-quarters of the way up the front door. Your eyeline is also the true horizon, but, in reality, you will only see this when looking out to sea, or across an enormous flat plain.

Vertical lines should always be vertical in your picture except on rare occasions when your subject is a very tall building.

For any single building, the lines of the roofs, gutters, and the tops and bottoms of windows and doors (which a spirit level would show as level) all converge to a single 'vanishing point' on your eyeline. This principle also applies to all buildings in a straight row or in parallel rows. If, from your viewpoint, you can see two sides of a building, there will be two vanishing points, one for each side.

On the other hand, if you can only see one side of the building, there will be just one vanishing point – straight in front of you – and this is only for the sides of the building that you cannot see! The tops of the wall, doors and windows that are visible, are parallel to your eyeline.

Try this exercise in constructing a house on flat ground. Then attempt to create a curved road.

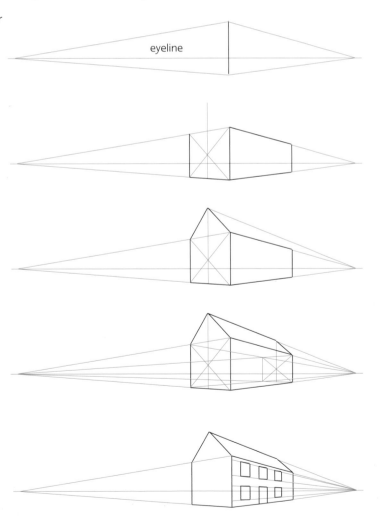

1. Establish your eyeline, then draw a vertical line for the corner of the building that is nearest to you. You are standing on level ground, so this will extend both below and above your eyeline. Now draw in lines from the top and bottom of the vertical to the vanishing points.

2. Draw verticals at the ends of each side of the building. On the gable end, draw diagonals from corner to corner to determine the centre of the wall in perspective. Draw a vertical through this point up to the top of the roof.

3. Draw a line from the top of the vertical to the vanishing point to define the roof line, then draw in the oblique lines of the sloping roof.

4. Using the same technique as in step 2, draw a vertical line for the middle of the back gable end, then complete the roof.

5. Now add the door and windows, remembering that same-size objects become smaller the further away they are.

ROADS AND RIVERS

The sides of roads and rivers also converge to vanishing points on the eyeline.

eyeline

The sides of a flat straight road or river converge to a vanishing point on the eyeline.

eyeline

The sides of roads that go down- and uphill converge to vanishing points below and above the eyeline respectively.

eyeline

A curved road or river can be broken down into a series of blocks, like paving slabs, with the sides of each converging to a different vanishing point on the eyeline.

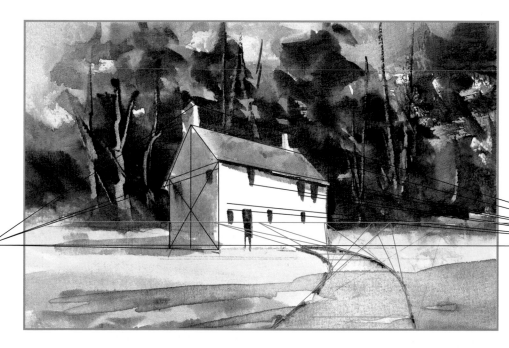

The eyeline for this colour sketch is just above the ground level at the house. The basic perspective lines for the house (shown in red) converge to two vanishing points on the eye level. The curved road goes uphill from the viewpoint, and its sides converge to various vanishing points on a line above eye level.

eye level

MEASURING ANGLES

When painting from a photograph, measure angles with a protractor and transfer them onto the drawing.

On site, place your pencil on the drawing at the point you want to start, then, without looking at the paper, look at the actual scene and draw the angle. You will be amazed to find that you have copied the angle fairly accurately. This technique is called contour drawing and everybody can do this.

ROCKS, HILLS AND MOUNTAINS

The lack of aerial perspective and poor shapes are the two most common faults that students display when they paint landscapes that include rocks, hills and mountains.

Aerial perspective, as opposed to the mechanical angles, shapes and sizes of linear perspective, uses colour to define depth and distance. Particles in the atmosphere make distant objects less distinct. As objects get further away, they get paler, bluer and more soft edged, and the tonal difference between light and dark areas also becomes less pronounced.

Mountains, for example, become bluer as they recede into the distance because the blue part of the spectrum passes through the atmosphere more easily than the red and yellow parts. I achieve soft edges on distant mountains by using the dry-in-wet techniques (see page 17).

The dreaded green is another big problem with beginners. There is a lot of green in most landscapes, but using the same green for both the distant and foreground parts of a composition flattens everything out and makes individual shapes difficult to distinguish.

Another problem, which I stress time and time again, is about poor, uninteresting shapes. So many paintings are ruined by placing 'Egyptian pyramids' in the middle of rolling countryside!

I remember a student asking the artist William 'Skip' Lawrence for a critique of one such painting. Skip's initial comment was: 'It has boring shapes'. The student justified his effort by saying that he had painted what was there, to which Skip replied: 'Well, don't go there again!'

Decide where your sunlight is coming from, then draw your mountains. Remember that you can use your own shapes, colours, angles, sizes and tones. Use shadows to divide your shapes into even better ones. This is being creative. You may not regard yourself as creative (it is something other people do), so change the word to *thoughtful* then, if you spend a little time being extra thoughtful, you might just end up painting a winner!

Remember that good shapes make great pictures!

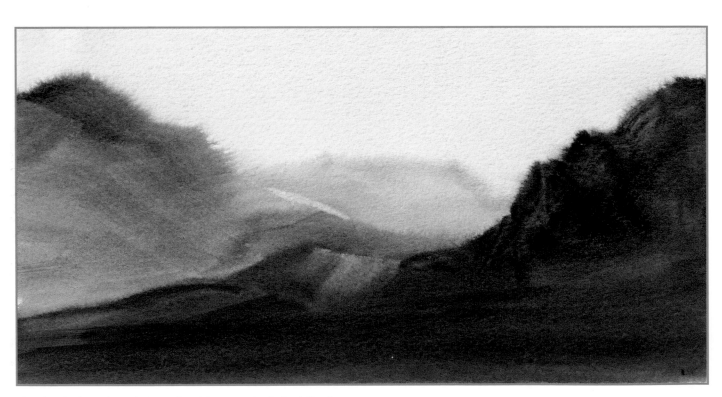

This sketch shows how the use of aerial perspective helps infer distance.
The mountains get softer, bluer and paler as they get further away.

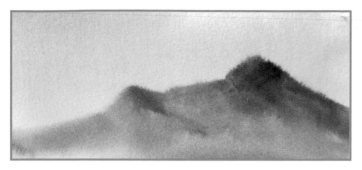

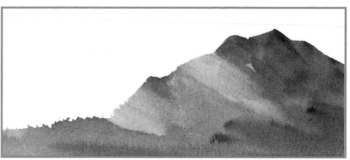

The soft edges and feeling of distance of these mountains were created using the dry-in-wet technique.

The angled highlights, and the broken edges on the slopes of this mountain were created by brushing a dry paper towel across the still wet colour.

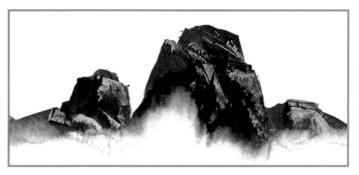

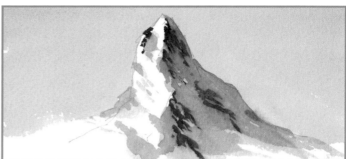

Look for interesting shapes. If you cannot see any, use your imagination to create some! I used the blade of a razor to move wet colour around within the painted shape to create texture and highlights. The spray in the foreground is the result of lifting off colour with a sponge.

Snow must be paler than the sky, and the shadows on the snow must be darker than the sky. For this sketch, I painted a wash of Winsor blue across the sky area and over all the areas of snow shadows on the mountain. I then used mixes of ultramarine blue and touches of permanent rose to strengthen the snow shadows and to add the dark tones.

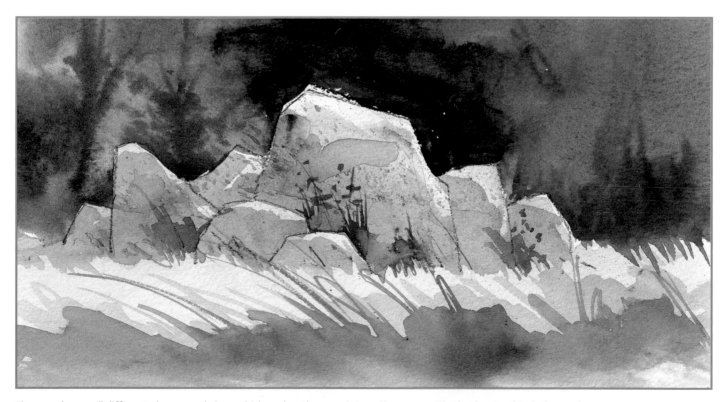

These rocks are all different shapes and sizes which makes them an interesting group. The background is dark, yet the shadows are pale; a combination that gives the impression of sunlit glare on the rocks. Aerial perspective – the use of cool, dark greens in the background and pale, warm ones in the foreground – gives depth to this simple composition.

Two-colour landscape

Painting with a limited palette of just a few colours helps to create a natural harmony throughout a painting. For this first step-by-step demonstration, I chose to use just Winsor blue and burnt sienna. These two colours are roughly opposite each other on the colour wheel and mixes of them will, therefore, produce a wide range of colours, including some good darks. Placing these strong darks adjacent to light areas enables you to produce a powerful sunlit effect.

The focal point of this composition is the group of buildings, and the shapes of the road and the hedges lead the eye to them. The branches of the trees on the left-hand side also point in their direction. The rocks in the foreground offer the chance of creating interesting shapes and their position makes the shape of the road more exciting. The two figures in the distance were an afterthought, added to provide both scale and interest to the painting.

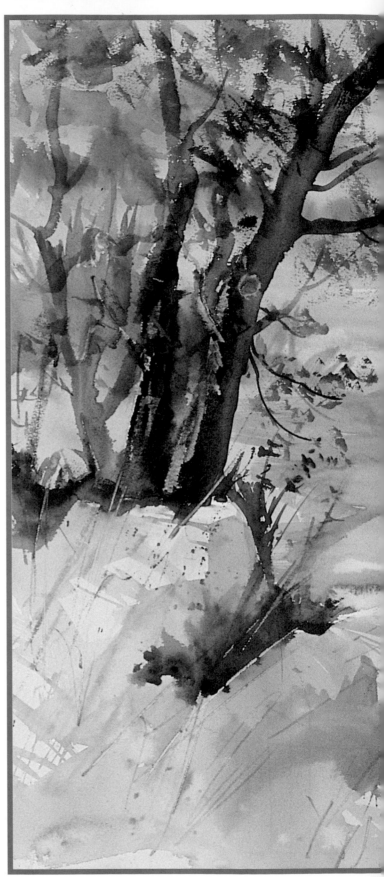

Original pencil sketch used to compose the painting.

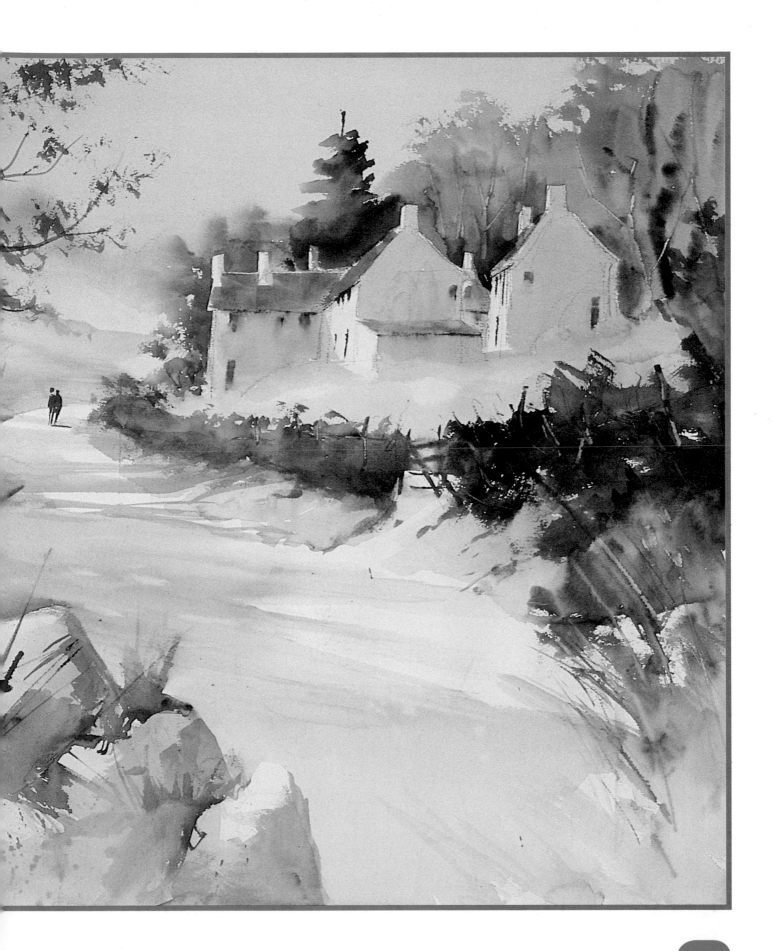

You will need

185gsm (90lb) acid-free rag paper with a
NOT (cold pressed) surface finish
Graphite stick
25mm (1in) flat brush
no. 3 rigger brush
13mm (½in) scraper brush
Colours

burnt
sienna

Winsor
blue

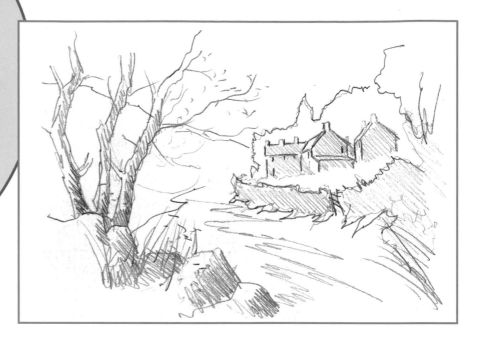

1. Referring to the original pencil sketch above,
use a graphite stick to draw the basic outlines
of the composition onto the paper.

2. Use the 25mm (1in) flat brush to wet
the sky area down to just below the hill and
trees, but leave the shape of the house dry.

3. Mix a wash of Winsor blue, then lay this into the wet sky, weakening the mix as you work downwards.

4. Mix Winsor blue and burnt sienna to make a dark blue/green, then lay this colour into the distant hills wet-in-wet.

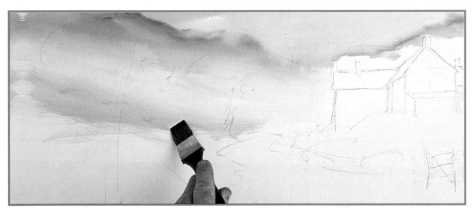

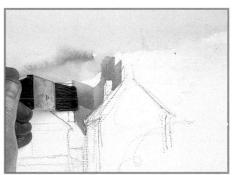

6. Using a strong green and the full width of the brush, cut round the shape of the roof for the start of the background trees.

5. Use a pale burnt sienna wash to paint the lower hills, then introduce a line of blue in the foreground.

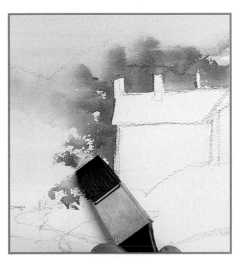

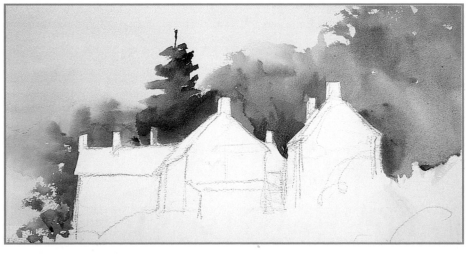

7. Flatten the brush to make random marks for the bushes.

8. Mix different tones of green and brown, then build up the mass of foliage behind the buildings.

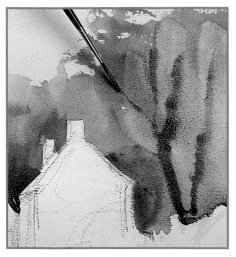

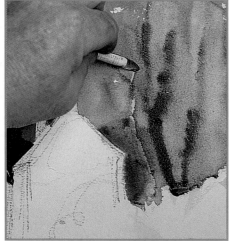

9. Use the rigger brush to paint the tree trunks.

10. Use the handle of the scraper brush to scrape out a few more trunks.

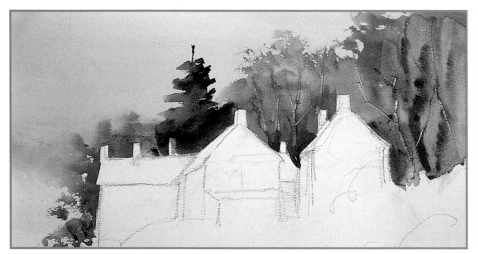

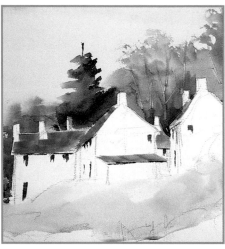

11. Using a flattened brush, add touches of broken foliage to the top of the trees.

12. Use neat burnt sienna to lay in the roofs.

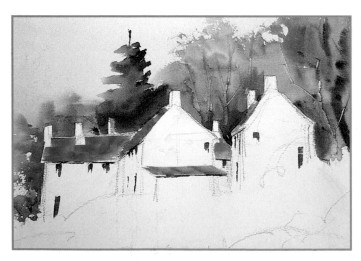

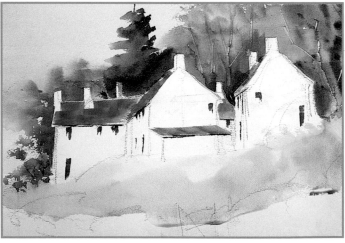

13. Make a mix of equal parts of both colours, then lay in the gutters and windows.

14. Use a mix of burnt sienna with a touch of Winsor blue to block in the fields in front of the buildings.

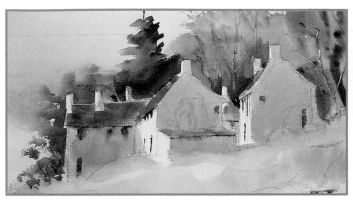

15. Now mix Winsor blue with a touch of burnt sienna, then paint in the shadows on the walls and roofs.

16. Wet the left-hand hills, mix a dark blue-green, add some trees in the middle distance, then soften the bottom edges with clean water.

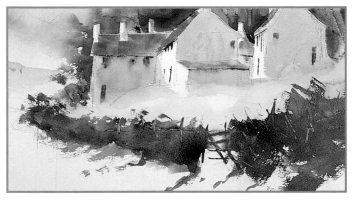

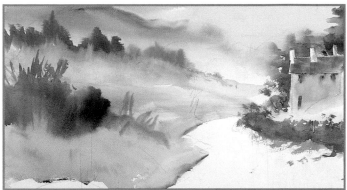

17. Lay in the hedge with random mixes of the two colours; use cool, weak colours in the distance, and warm, strong ones in the foreground. Use the handle of the scraper brush to make indications of twigs and fence posts.

18. Working with weak washes of both colours block in the fields at the left-hand side then, while the paper is still wet, lay in some more trees and bushes. Use the corner of the brush to work more detailed areas.

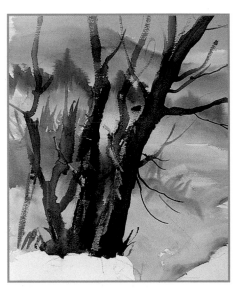

KNOTS ON TREE TRUNKS
Press your knuckle onto the wet paint, hold it there for five seconds, then lift it off to leave a knot.

19. Using the no. 8 round brush and a warm dark, lay in the tree trunks and branches. Create highlights with the handle of the scraper brush.

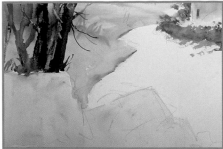

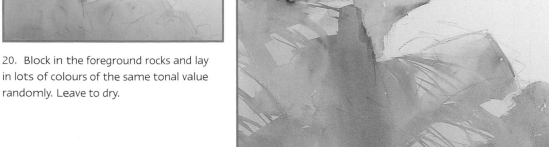

20. Block in the foreground rocks and lay in lots of colours of the same tonal value randomly. Leave to dry.

21. Glaze weak washes of both colours over the rocks to create areas of shadow.

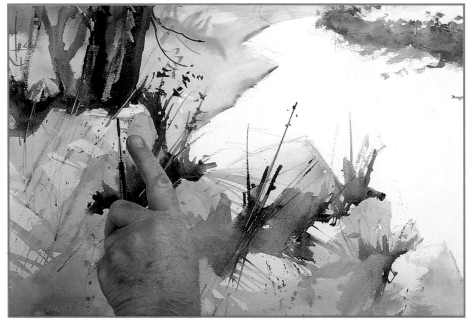

22. Mix a dark green, then use the rigger brush to add small bushes and grasses at the base of the trees and in between the rocks. Use the handle of the scraper brush to scratch through in places. Splatter spots of colour by tapping the rigger with your finger.

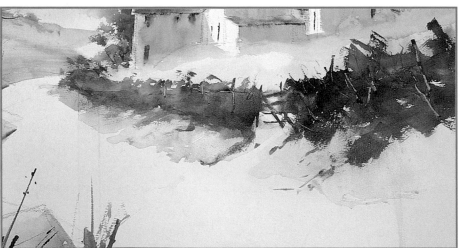

23. Wash in the grassy bank on the right under the hedge; use cool tones in the distance and warmer ones in the foreground.

24. Add some foliage at the right-hand side, taking colour up to link with the background trees.

25. Lay in shadows across the road, then, while the paint is still wet, use a dry brush to lift out some dappled highlights.

26. Add some deep shadows in the rocks to bring them forward and above for the road.

27. Start to work the foliage in the large group of trees, using a criss-cross brush action to make large marks.

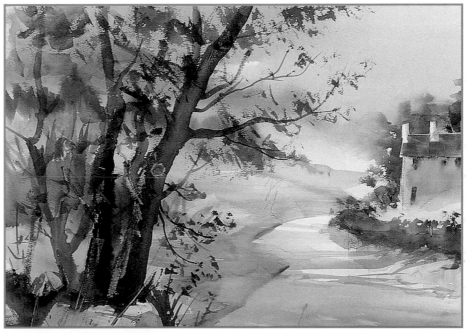

28. Continue working the rest of the foliage, making the marks smaller and paler as you work out outwards. Use the dry-on-dry technique and a damp brush to apply the very small leaves at the tips of the branches.

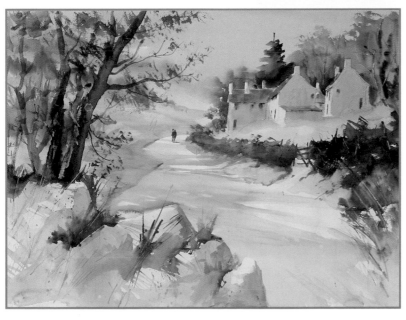

The finished painting.

Having stood back and looked at the whole picture, I decided to add two small figures as a focal point.

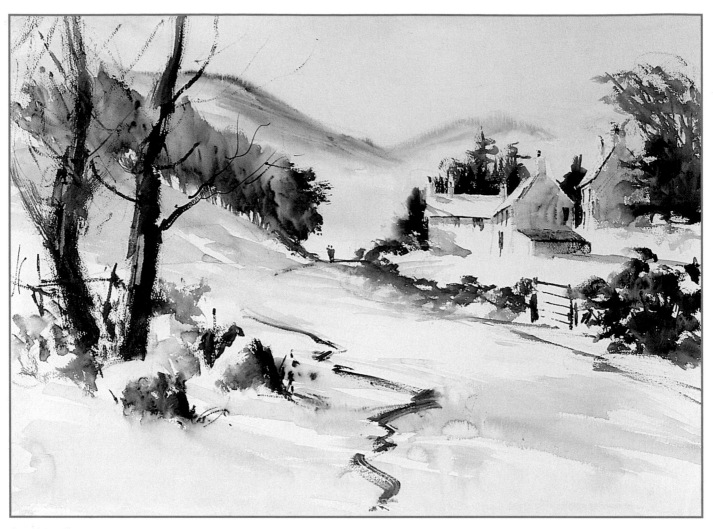

Sunlit Walk

Size: 710 x 510mm (28 x 20in)

This monochrome painting is a similar composition to the two-colour landscape shown on pages 36–43, but, as there are fewer leaves on the trees, there is a better view of the distant mountains.

It has the same basic concept as the small tonal sketches shown in many of the projects, but here I went on to produce this much larger and more detailed finished painting. A single colour painting – this was painted with burnt umber – relies solely on the relationship of light and shadow to produce the desired effect.

Towards the Brow

Size: 485 x 470mm (19 x 18½in)

I used just three colours for this painting: ultramarine blue, cadmium scarlet and lemon yellow.

Although the farmhouse is one of the main components of this painting, it acts as a stepping stone to the focal point of the composition, the two figures on the brow of the hill. Notice that all of the other 'lines' – the road, the wall and even the shapes of the trees – lead the eye to them.

It is not common practice to paint landscapes in this format; they are normally worked within horizontal or vertical rectangles (usually referred to as landscape or portrait format). Occasionally, however, I like to break all the rules, so this one is roughly square.

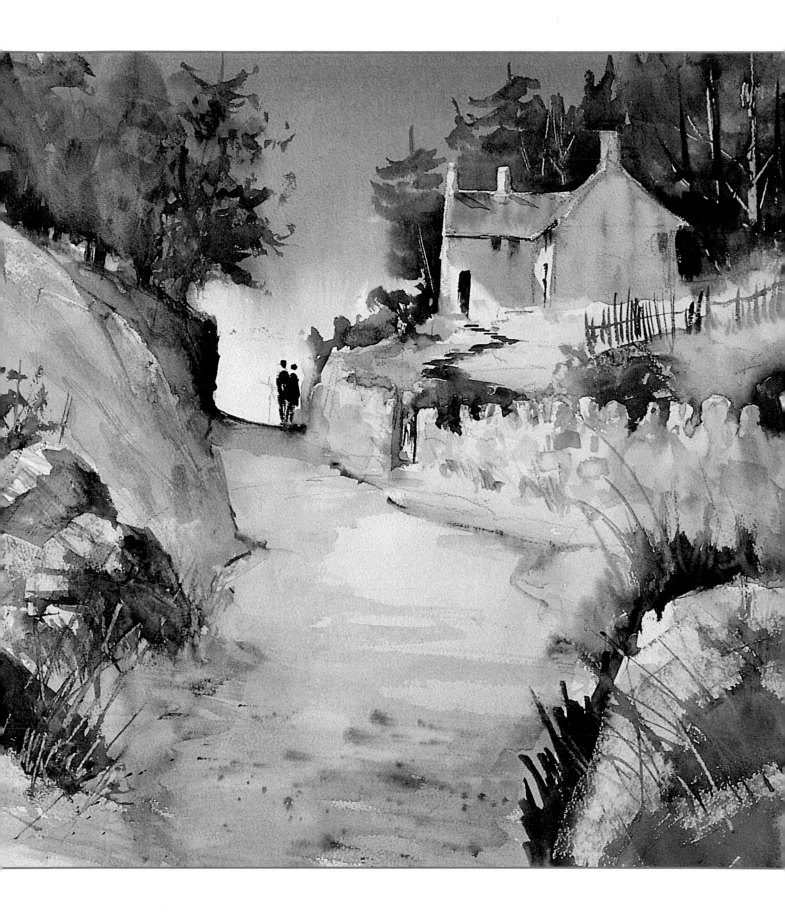

Full-colour landscape

I love painting panoramic landscapes, especially scenes such as this one with its tranquil lake and a background of mountains extending far into the distance.

Soft edges to the shapes of the mountains help indicate their size, and an exaggerated aerial perspective (the mountains are warmer, darker and more distinct as they get closer) gives a feeling of distance. Note that, in this composition, each mountain has a completely different shape. Exact repetition of shapes does not look right in a painting, even if it is that way in reality. Remember that, unlike a photograph, a painting is your interpretation of a scene, and you can make as many changes as you want to give your composition more interest.

Diagonal lines in a painting generally denote movement and drama, whereas horizontal and vertical lines give the impression of stillness and peace. The tranquil quality of this expanse of water is accentuated by the use of horizontal and vertical lines for the reflections at the edges of the lake.

These reflections are created by painting the colours of the reflected objects into the wet water area with a thirsty brush, a technique which retains and softens the shapes.

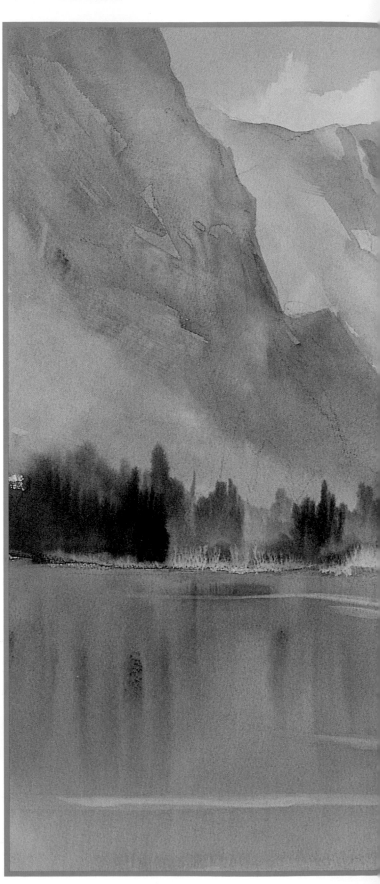

The tonal sketch used as the basis for this demonstration. It was drawn when the sun was high in the sky. Contrary to the common belief that shadows are darkest at midday, the light reflected from other surfaces makes them quite pale. I accentuated this fact with the shadows on and around the building.

You will need

300gsm (140lb) paper with a NOT (cold pressed) surface finish
Graphite stick
25mm (1in) flat brush
13mm (½in) scraper brush
Paper towel
Colours

Winsor blue permanent rose cobalt blue raw sienna

burnt sienna cadmium scarlet lemon cadmium yellow

burnt umber ultramarine blue

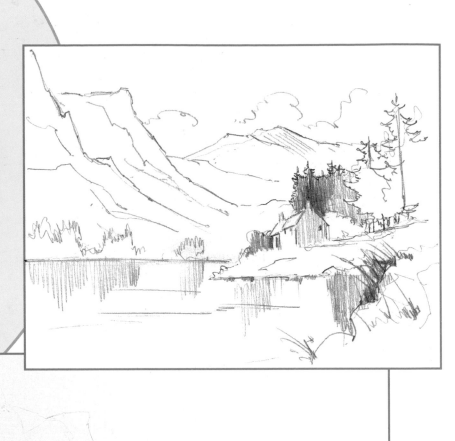

1. Use a graphite stick to transfer the outlines of the composition 1. Use a graphite stick to transfer the outlines of the composition onto the watercolour paper.

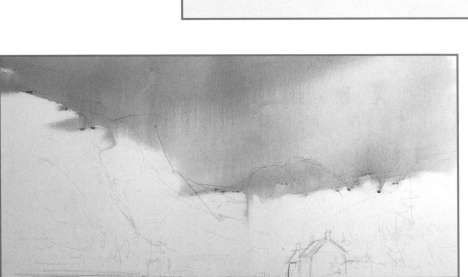

2. Using the flat brush, wet the sky area, then lay in a wash of Winsor blue, strengthening the colour at the top left-hand corner.

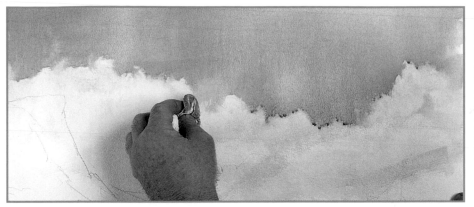

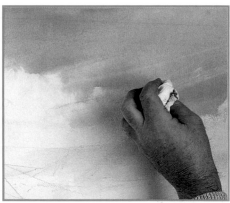

3. While the sky area is still wet, use a clean paper towel to dab out the top edges of the clouds.

4. Flick a clean paper towel across the paper to form streaky clouds.

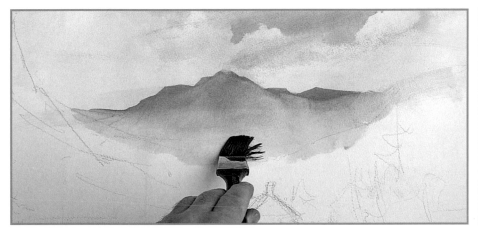

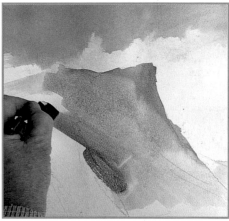

5. Using a mix of Winsor blue with a touch of cadmium scarlet and the flat brush, block in the far distant mountains, softening the bottom edges with clean water. Use a paper towel to drag colour from the hard edges at the top.

6. Add more cadmium scarlet to the mix, then start to block in the top of the more distant hills at the left-hand side. Add raw sienna and permanent rose as you work down the slope.

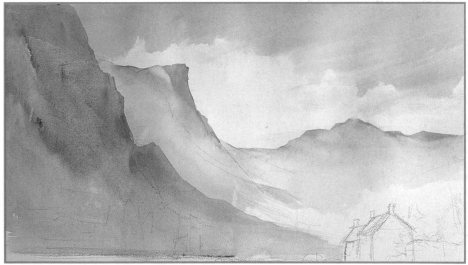

7. Allow the colours to soften and blend together. Use a clean paper towel to lift out a subtle highlight, then leave to dry.

8. Block in the near hills with burnt sienna, then drop in touches of the other colours on the palette. At this stage, I decided to increase the height of these hills, so I pumped in some Winsor blue at the top. Darken the right-hand edges to lift them away from the distant hills. Finish this stage with touches of lemon yellow at the base of the hills, across to the buildings.

9. Mix lemon yellow and a touch of cadmium scarlet, then block in the right-hand hills. Add some Winsor blue, then soften the bottom edges with a clean brush.

10. Use cobalt blue, with touches of permanent rose and cadmium scarlet, to add shadows and shape to the hills at the left and right.

11. Mix various tones of green with Winsor blue and burnt umber and, while the paper is still wet, use a thirsty brush to lay in trees along the horizon line.

12. While the trees are still wet, drop in clean water along the horizon line and allow backruns to form and denote patches of mist. Lift off excess water with a dry brush.

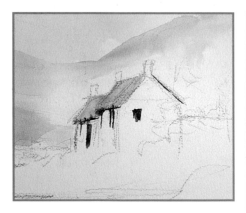

13. Use cadmium yellow to block in roofs on the buildings. While this is still wet, add a touch of cadmium scarlet. Mix burnt umber and ultramarine blue, then paint the gutters, windows and doors.

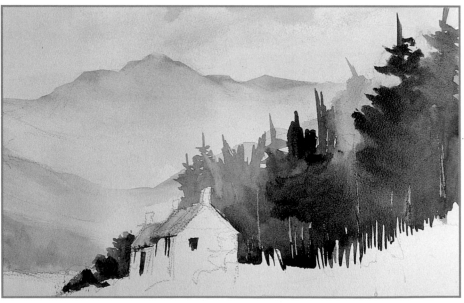

14. Mix greens with Winsor blue and burnt umber for the bushes to the left of the houses, then drop in touches of lemon yellow and cadmium scarlet. Use the greens to block in the large stand of trees with touches of burnt sienna. Use the handle of the scraper brush to scratch out some trunks.

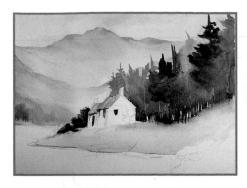

15. Block in the grassy bank with lemon yellow, then pump in raw sienna in foreground and Winsor blue in the distance.

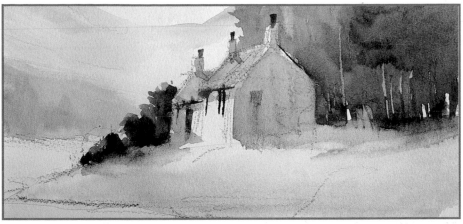

16. Mix cobalt blue with touches of permanent rose and cadmium scarlet, then block in the shadows on the walls and chimneys and the cast shadows on the grassy bank. Use burnt umber and ultramarine blue to add the tiny chimney pots.

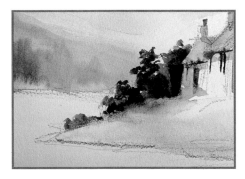

At the end of step 16, I stood back and looked at the shapes in the painting. I did not like the shape of the foliage at the left-hand side of the building, so I changed it. I also added another small bush at the water's edge.

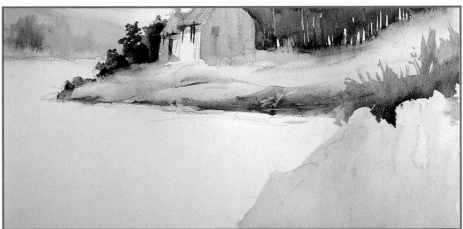

17. Use lemon yellow and permanent rose to block in the basic shape of the foreground rocks. Use burnt umber and ultramarine blue to add shape and shadow in the grassy bank and to define the top edges of the rocks.

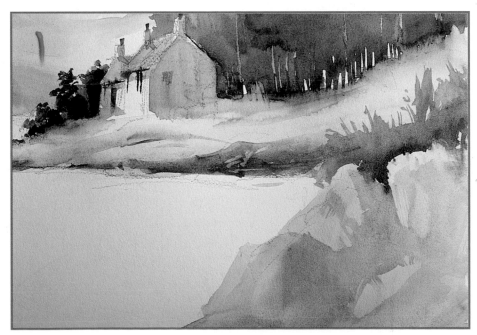

18. Mix ultramarine blue with touches of permanent rose and cadmium scarlet, then add shape and shadows on the foreground rocks. Leave to dry.

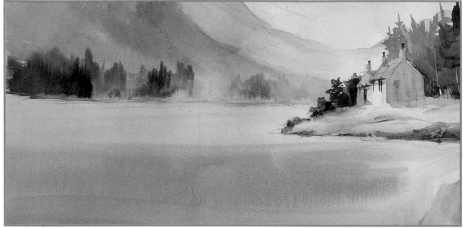

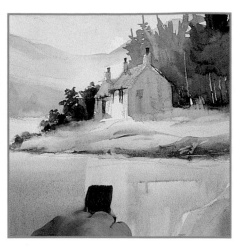

19. Thoroughly wet the lake area, then lay a wash of Winsor blue.

20. Use a damp, thirsty brush to pull out reflections of the buildings.

21. Add ultramarine blue to darken the far side of the lake.

22. Use vertical strokes to pull the colour downwards to create the reflections of the trees.

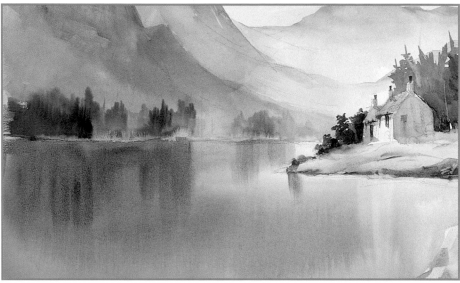

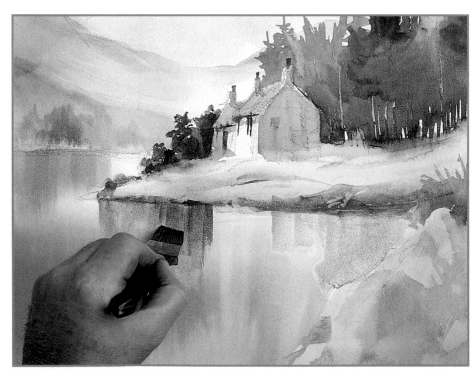

23. Using mixes of lemon yellow, raw sienna and Winsor blue, pull down reflections of the grassy bank.

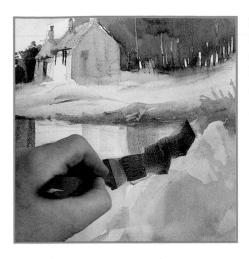

24. Use a mix of Winsor blue and burnt umber to add reflections of the tree colours behind the rocks at the right-hand side. These marks pull the rocks away from the background.

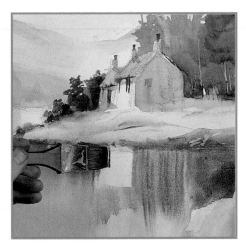

25. Paint the reflections of the buildings.

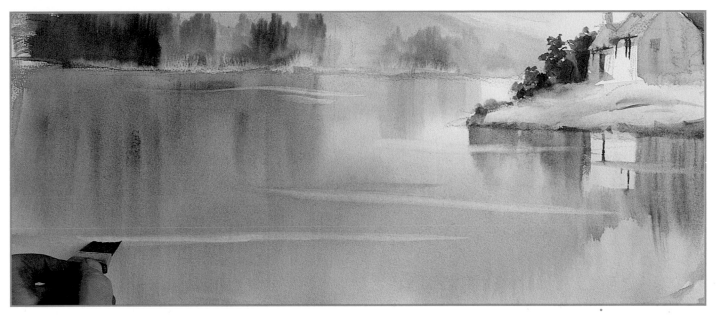

26. Use a clean dry brush to pull out horizontal ripples.

27. Finally, using a mix of Winsor blue and burnt umber, add some spiky grasses on the foreground rocks to help define shape.

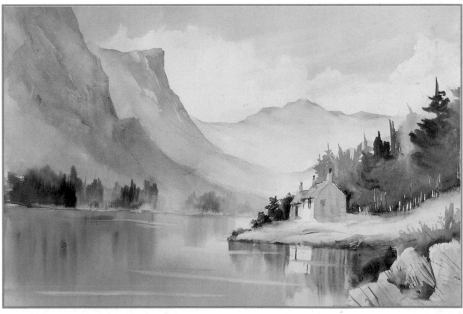

The finished painting.

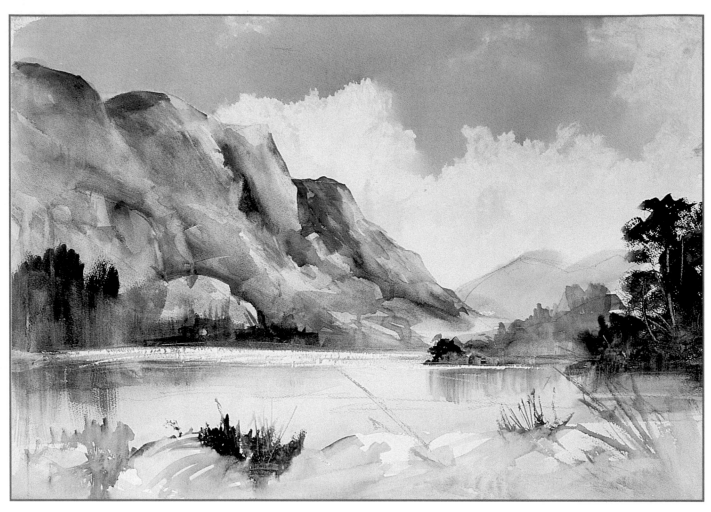

Tal-y-llyn Lake, West Wales
Size: 710 x 510mm (28 x 20in)

The soft, out-of-focus reflections on the surface of the lake allow the eye to move through the painting to the distant mountains. The foreground details, usually the warmest and sharpest parts of a painting, were left soft and pale, with gaps between each piece of foliage to help the eye enter the picture. I used the corner of a razor blade to scratch the highlights across the distant surface of the lake when all the paint was dry.

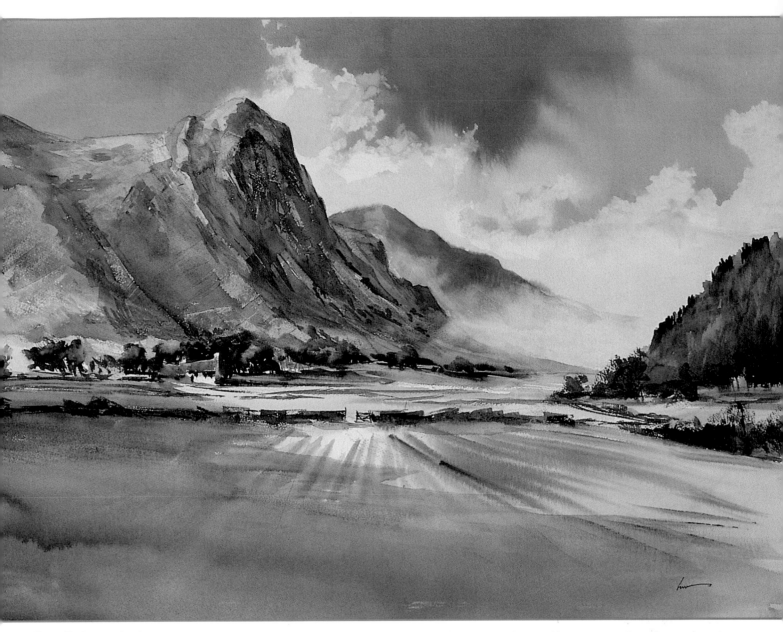

Bird Rock, West Wales

Size: 710 x 510mm (28 x 20in)

Bird Rock is in a hidden valley on the west coast of Wales. Many moons ago, the sea came right up the valley and cormorants nested on the rock. When the sea eventually receded, however, nobody told the cormorants! The rock dominates the valley, and it must be the focal point of any composition. The shapes and aerial perspective all lead the eye to this rock. The misty areas in the distance were created by sponging out the colours from the background. Compare these edges with those of the clouds which were lifted out with a dry paper towel.

Waterfall

I feel that the power of a waterfall requires powerful shapes. To this end I sketched the falls from different angles to find the most striking viewpoint. I have included two of these here. The top sketch, drawn face-on to the falls, is the most obvious choice of viewpoint. The bridge, however, has a horizontal top edge and a rather boring shape. Also, the shape of the first section of the falls is totally lacking in interest.

Compare this with the second sketch for which I moved a little closer, viewing the bridge from low down on the left-hand side. From this viewpoint, the bridge has an angled top edge, giving it a different and more interesting shape. The shapes of the rocks on the left-hand side also become more angular, and these combine to create an exciting shape for the first section of the waterfall. Notice that this viewpoint affects the shape of the composition, changing it from a roughly square to a portrait format, which emphasises the height of the falls and makes a more dramatic painting.

The edge texture of shapes plays an important part in this painting. Rough and soft edges are symbols for moving water; sharp edges would make the water look stationary. Sponging out spray has the dual effect of producing better shapes for both the water and the rocks.

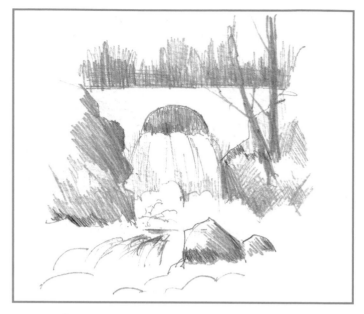

Compare this pencil sketch, drawn face-on to the falls, with the tonal sketch below which was painted from a lower viewpoint.

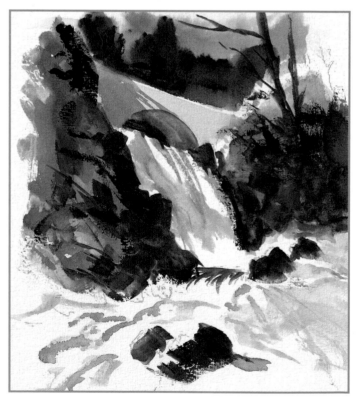

This tonal sketch was used to compose the painting.

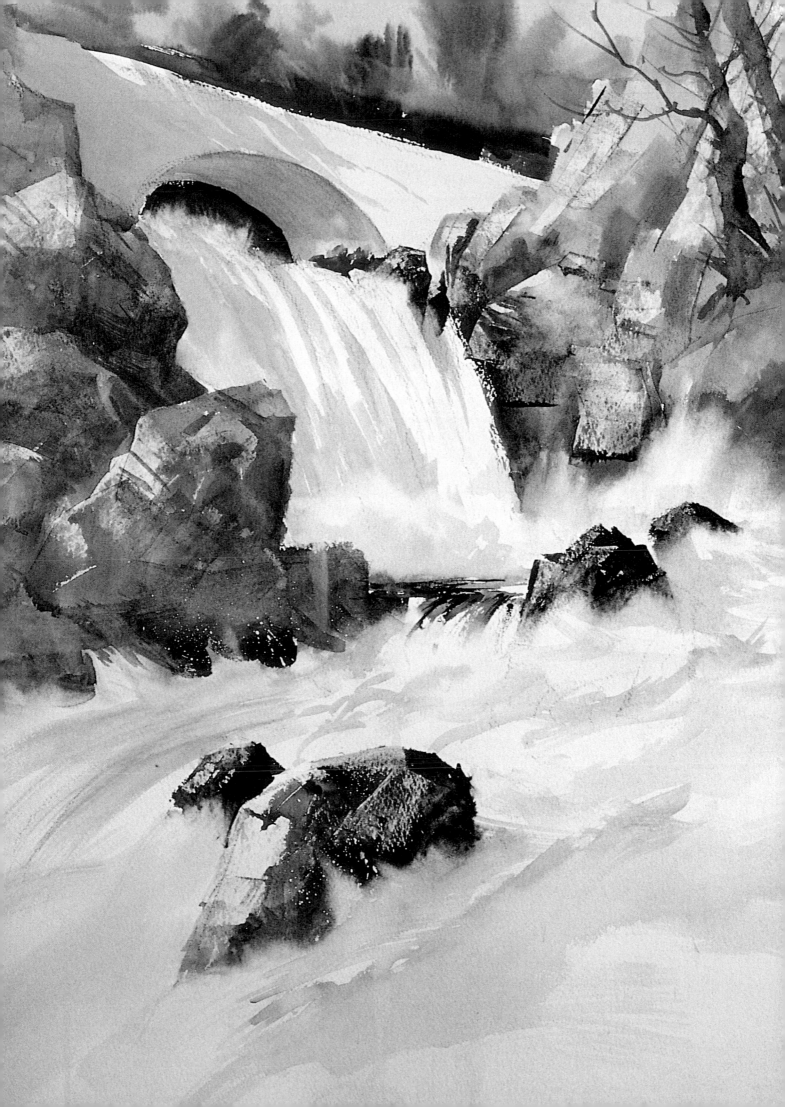

You will need

300gsm (140lb) paper with a NOT (cold pressed) surface finish

Graphite stick

25mm (1in) flat brush

13mm (½in) scraper brush

no. 3 rigger brush

Sponge

Razor blade

Process white

Colours

 aureolin

 permanent rose

 cobalt blue

cadmium scarlet

 Winsor blue

 burnt umber

 burnt sienna

ultramarine blue

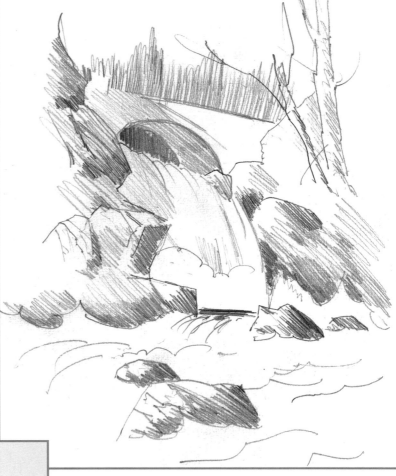

1. Use a graphite stick to sketch the outlines of the composition onto the watercolour paper.

2. Use the flat brush and separate washes of aureolin, thin permanent rose and thin cobalt blue to block in the bridge. Allow the colours to blend on the paper, then leave to dry.

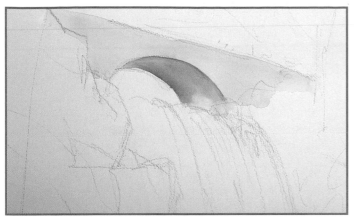

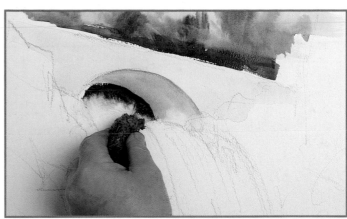

3. Mix a wash of cobalt blue with touches of permanent rose and cadmium scarlet, then glaze the shadows on the underside of the bridge.

4. Use a wash of cobalt blue to lay in the sky, then, while this is wet, use mixes of Winsor blue and burnt umber to add trees behind the top of the bridge. Use the same mix to paint the foliage through the arch, then use a clean damp sponge to lift out colour to form spray.

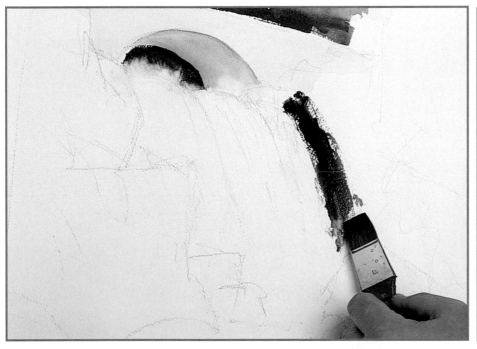

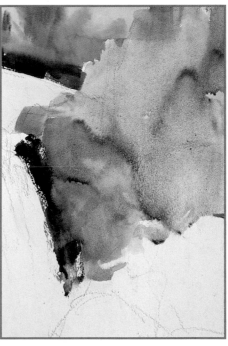

5. Use a mix of burnt sienna and ultramarine blue and a flattened brush to form the line of the waterfall.

6. Using washes of aureolin, permanent rose, ultramarine blue and burnt sienna, block in the rocks at the right-hand side and allow the colours to blend together.

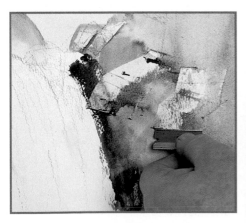

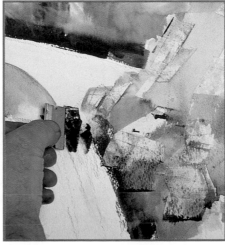

7. Now use the flat of a razor blade to scrape interesting shapes into the rocks.

8. Use a clean damp sponge to soften the top edges of the mass of rocks. Mix burnt sienna with ultramarine blue, then add two large rocks at the top of the waterfall. Razor out some highlights on these rocks.

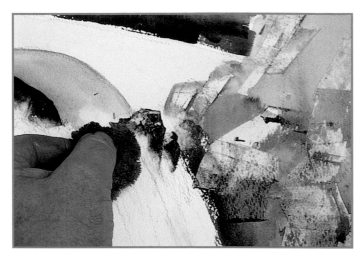

9. Use a clean sponge to soften the bottom edges of the two rocks at the top of the waterfall.

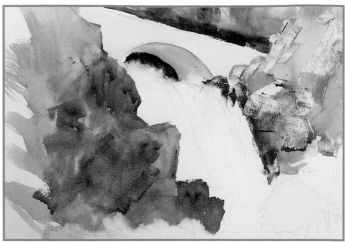

10. Use mixes of burnt sienna, ultramarine blue and burnt umber to block in the rocks at the left-hand side – use cooler colours at the top of the rocks. Soften the edges at the water line with a sponge.

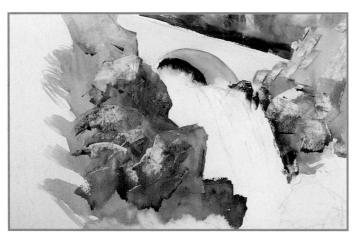

11. Use the razor to create interesting shapes on the rocks and to highlight the sunlit surfaces.

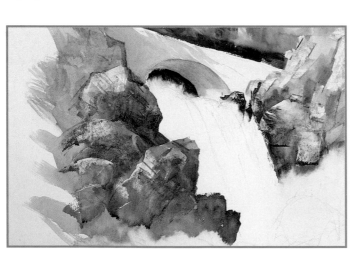

12. Mix some stony greys with cobalt blue, permanent rose and cadmium scarlet, then add shadows and shape to the rocks on both sides of the falls. Use the same colours to paint the cast shadows on the bridge.

13. Use burnt sienna to lay in the tree trunks at the right-hand side. Add ultramarine blue to the burnt sienna and apply shadows to the trunks. Use the handle of the scraper brush to create highlights. Use the rigger brush to paint in some branches and twigs.

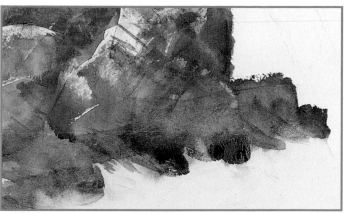

14. Mix a dark from ultramarine blue and burnt umber and block in the tops of two rocks at the base of the waterfall. Add touches of cadmium scarlet, then use the razor to create shape and highlights. Soften the bottom edges of these rocks with a sponge.

15. Use the same mixes as step 14 to apply dark areas at the bottom of the left-hand rocks.

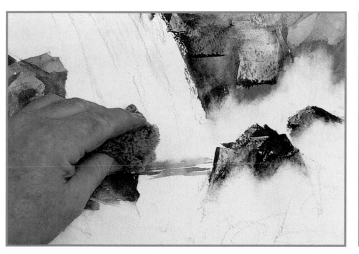

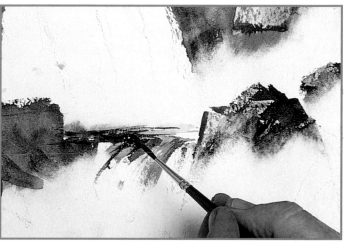

16. Add a touch of cadmium scarlet to cobalt blue, then paint a few horizontal lines to define the still water behind the rocks. Use a sponge to soften their top edges.

17. Add touches of burnt umber and ultramarine blue to the cobalt blue to make a darker blue, then add marks to the water to define movement between the rocks.

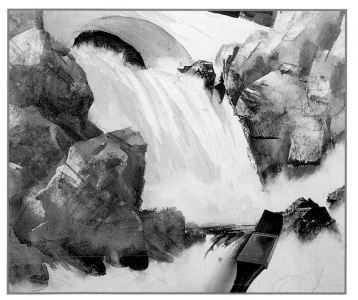

18. Make a weak wash of cobalt blue with a touch of cadmium scarlet, then flick the brush to create movement and shadows in the main waterfall. Sponge the bottom edges of all these marks, then add more shadows at the bottom.

19. Using mixes of burnt umber and ultramarine blue, paint the large rock formation in the foreground. Use the razor to create shape and highlights.

20. Use the cobalt blue and cadmium scarlet mix (see step 18) and sweeping strokes of the brush to build up movement in the water cascading round the rocks.

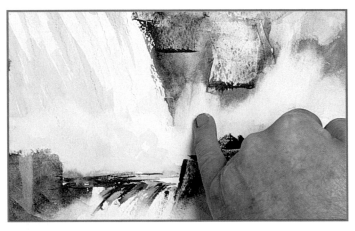

21. Apply process white with your finger to create spray, pushing the paint up into the rocks.

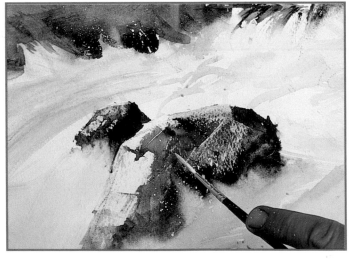

22. Spatter a few flying spots of spray over the dark areas of the foreground rocks by tapping a rigger brush, loaded with process white.

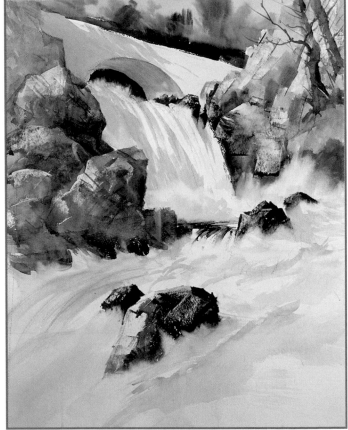

The finished painting.

Having stood back and looked at the composition after step 22, I decided to add some dark marks at the top of the waterfall to give a distinct break between the water and the underside of the bridge.

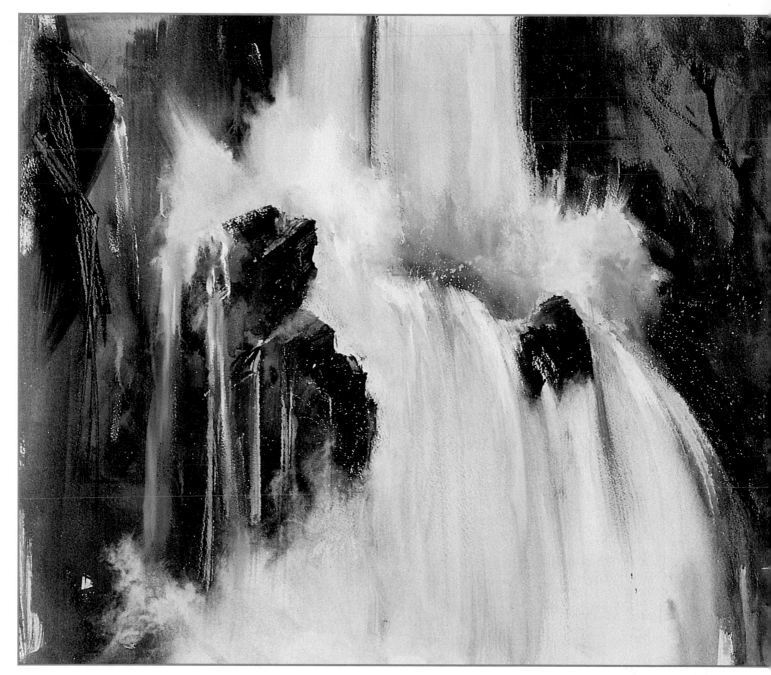

Powerful Water

Size: 610 x 530mm (24 x 21in)

This composition is completely imaginary and is an example of using abstract shapes and different painting techniques.

The most important part of the composition was to develop an interest in the white shape of the water, which is totally unpredictable and takes up about 50% of the picture area.

More interest is created by varying the edges of each shape; some are hard, others are soft and roughly textured, all of which are symbolic of moving water. The water pouring off the rocks at the left-hand side and the spattered spray effects were created by using opaque process white.

The drama of this scene is accentuated by combining cool and warm tones. A variety of cool tones form the water in the centre of the painting. These are contrasted by the warm colours used for the rocks, that also serve to highlight the overall effect.

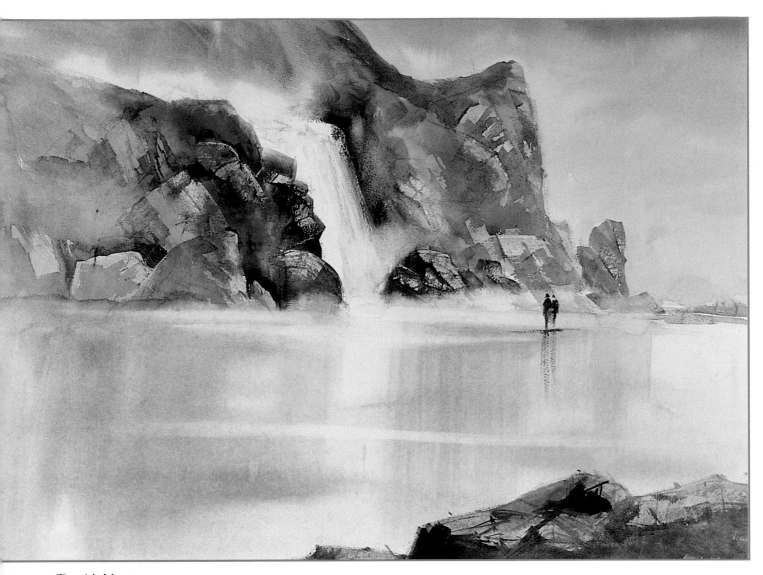

Tresaith Memory

Size: 735 x 535mm (29 x 21in)

The waterfall cascading onto the beach does exist, but, as I have not been to the beach for a long time, this painting is straight from the imagination. When composing it, I decided to enhance the size of the waterfall in relation to the beach and to use warm colours in the rocks. This practice is allowed because it is my painting! I also decided to add a couple of figures to give scale to the scene.

Opposite

Aberdulais Falls, South Wales

Size: 430 x 495mm (17 x 19½in)

The vertical format of this painting enhances the scene and gives prominence to the falls. The use of soft and rough edges indicates movement in the water. I used the corner of a razor blade to scratch out some sparkles in the water when the paint had dried.

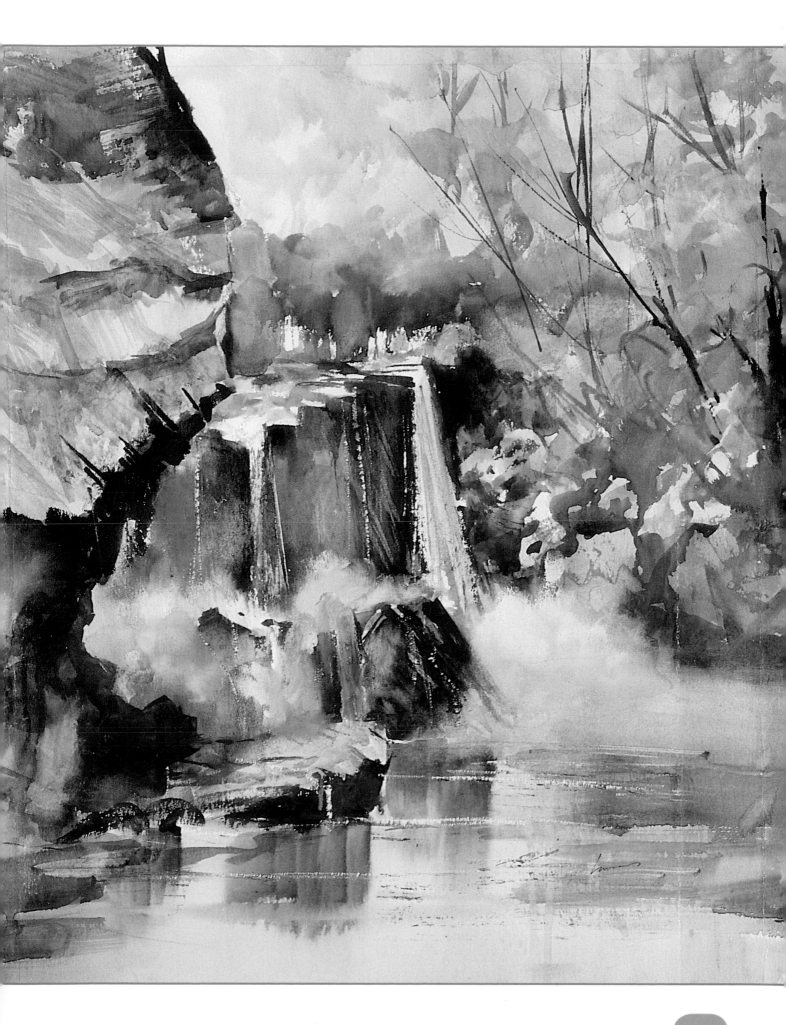

Seascape

It was very windy when I visited this beach and I wanted to capture that feeling in a painting. Rather than use horizontal and vertical lines that are normally associated with still, peaceful scenes, I used lots of diagonal lines and shapes at opposing angles. The rough edges on the cloud shapes, for example, helps create this mood and it is further enhanced by the shapes of the waves. Note that the focal point of this composition is simply a point (not an object) where the sea meets the beach in the bottom left quarter of the painting.

Rocks can be difficult to isolate from each other if you paint the colours exactly, so I tend to exaggerate the aerial perspective, making the furthest rocks cool (blue tones) and warming up the colours as the rocks become closer.

Soft and textured edges are applied to the base of the large rock formations where they meet the wet sand. Compare these edges with the rough ones used for the smaller, foreground rocks which are sticking out of dry sand.

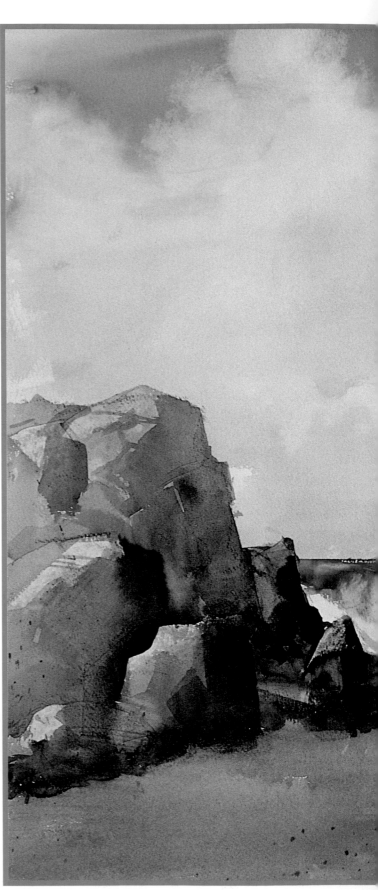

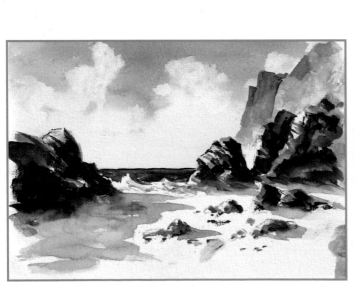

A monochrome tonal sketch of the beach scene.

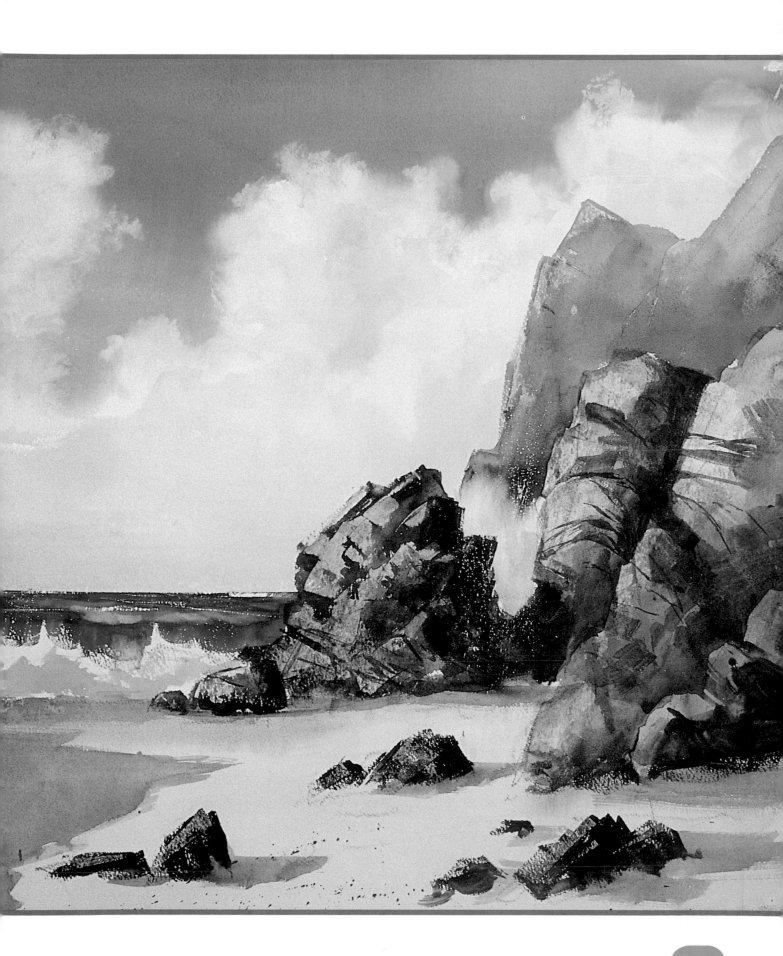

You will need

300gsm (140lb) woodfree, archival paper with a NOT (cold pressed) surface finish

Graphite stick

25mm (1in) flat brush

Sponge

Paper towel

Razor blade

Masking tape

Putty eraser

Process white

Colours

 Winsor blue cadmium scarlet ultramarine blue

 burnt sienna burnt umber

 raw sienna permanent rose

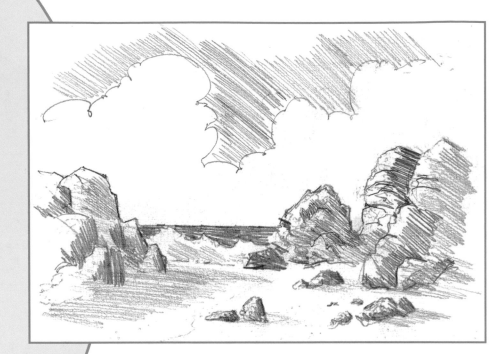

1. Sketch the outlines of the composition onto the watercolour paper. Use the flat brush to wet all the sky area, then brush in a wash of Winsor blue. Add a touch of cadmium scarlet to the mix and darken the top part of the sky.

2. Using first a sponge and then a clean piece of paper towel, work the top edges of the cloud formation.

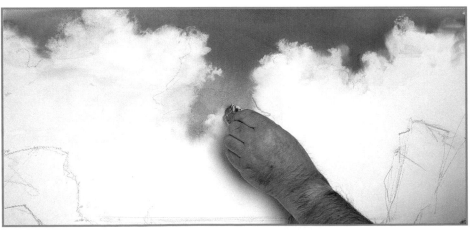

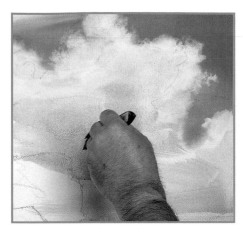

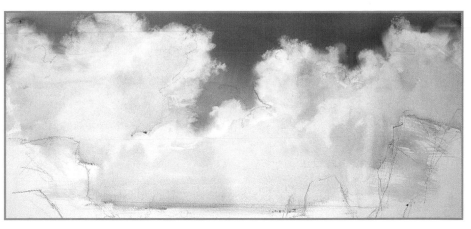

3. Re-wet the cloud area, use Winsor blue and cadmium scarlet to mix a grey, then block in the undersides of the clouds.

4. Use paper towel to lift out colour and create shape and form in the lower clouds and the area of spray between the rocks at the right-hand side.

5. Mix Winsor blue and burnt sienna, then block in the large rock in the middle of the composition. Add touches of raw sienna in places.

6. Use the razor blade to create surface textures on the rock.

7. I was not happy with the shape of this rock, so I increased its width by adding darks to the right-hand side. I used the same mix to add shadows over the whole shape.

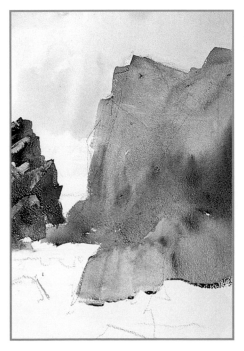

8. Using mixes of Winsor blue, raw sienna, permanent rose and burnt sienna, block in the cliffs at the right-hand side.

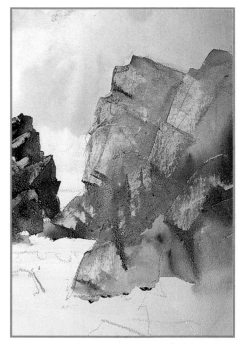

9. Use the razor blade to create shape, texture and highlights on the surfaces of the cliff.

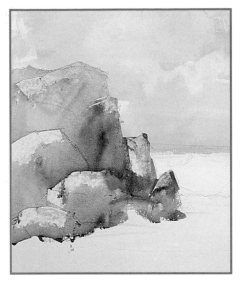

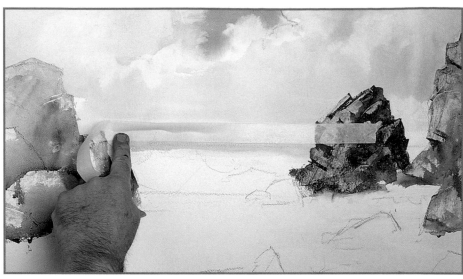

10. Use the same set of colours as in step 9 to block in the left-hand cliffs, then use the razor blade to create shape and texture.

11. Apply a length of masking tape along the horizon line and smooth down just the bottom edge.

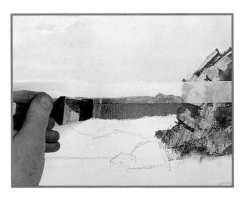

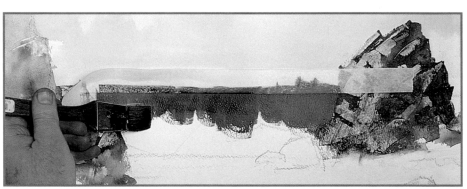

12. Mix Winsor blue with a touch of cadmium scarlet and paint in the sea along the horizon.

13. Flatten the brush to form rough edges at the top of the waves.

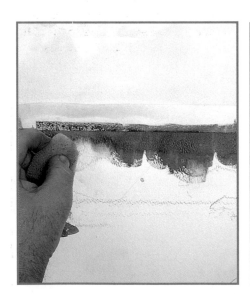

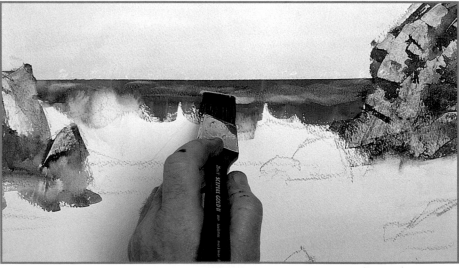

14. Soften the top edges of some of the waves with a clean damp sponge.

15. Remove the masking tape to leave a crisp, straight horizon. Use a clean, damp brush to lift colour out of the sea, to create swells and movement in the water.

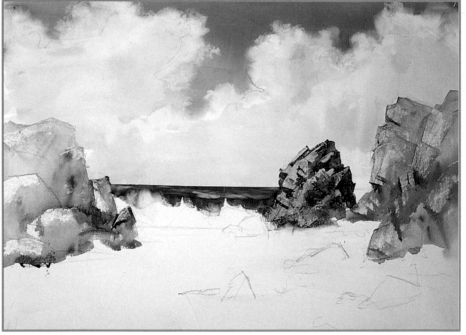

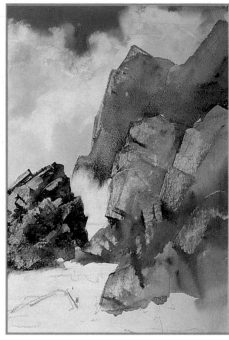

At the end of step 15, I stood back to look at the painting. The cliffs on either side were the same height and made the painting too balanced, so I decided to add more cliffs behind those at the right. Never be afraid of changing the composition as the painting progresses.

16. Overcome the problem of balance by using paler tones of the cliff colours used in step 8, to add taller cliffs behind those at the right-hand side. Use the sponge to recreate the spray at the bottom edges of these cliffs, and a razor blade to add texture.

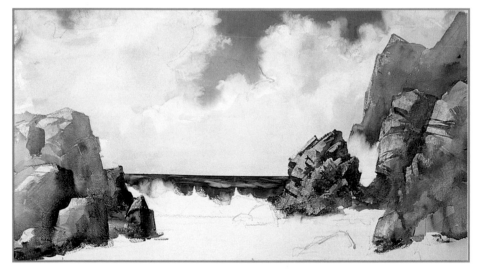

17. Mix ultramarine blue and a touch of cadmium scarlet to make greys, and use these colours to add shadows to the cliffs at both the left- and right-hand sides.

18. Wet the beach area, then use a wash of raw sienna to block in all the sand, including the small, pencilled rocks. Add a touch of burnt sienna in the foreground, to warm it up slightly, and a touch of Winsor blue to indicate wet sand in the distance.

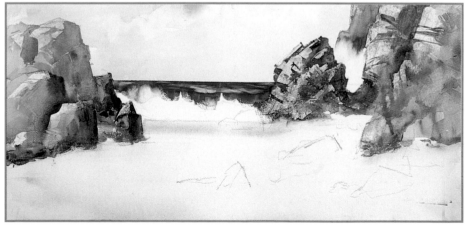

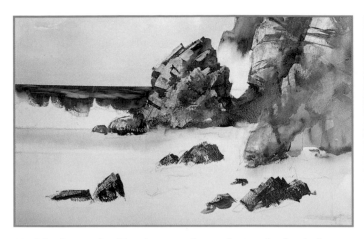

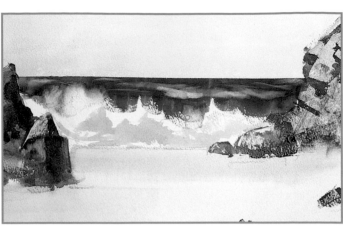

19. Mix ultramarine blue, burnt umber and a touch of cadmium scarlet, then use a dry brush to paint the rocks on the beach. The rough edges at the base of the rocks indicate dry sand. Use the razor blade to create shape and texture.

20. Mix Winsor blue with a touch of cadmium scarlet to add shadows in the breaking waves.

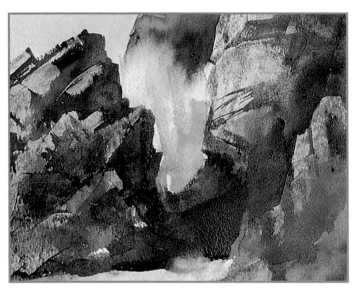

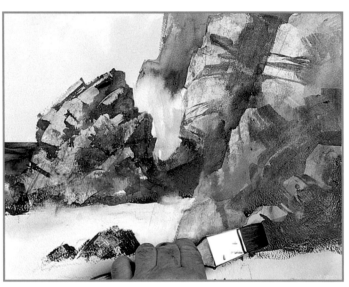

21. Use the same mix to add shadows in the spray between the rocks.

22. Mix ultramarine blue and burnt umber, then add shadows at the base of the cliffs. Soften some of the bottom edges with a clean damp brush.

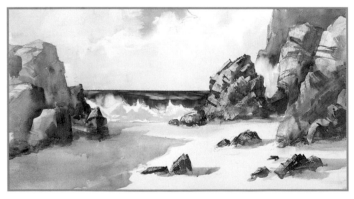

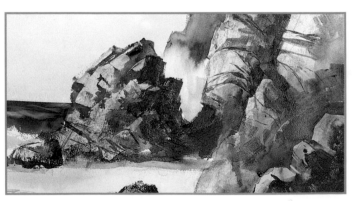

23. Mix ultramarine blue with touches of permanent rose and cadmium scarlet (to grey the mix), then paint in the cast shadows across the beach.

24. I was still not happy with the shape of the large rock, so I used the dark mix to alter it slightly. I also made subtle changes to the shapes and shadows on the right-hand cliffs.

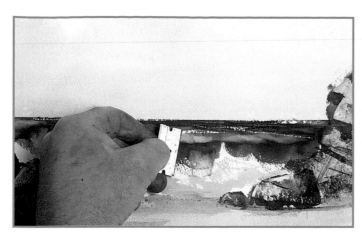

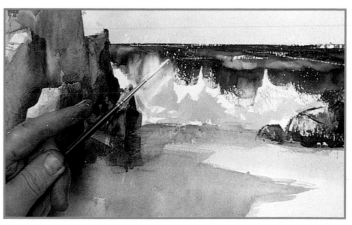

25. Use the razor blade to break the hard edge of the horizon line, and to add sparkles on the surface of the water.

26. Spatter process white, by tapping a loaded rigger brush with your finger, to create spray above the waves.

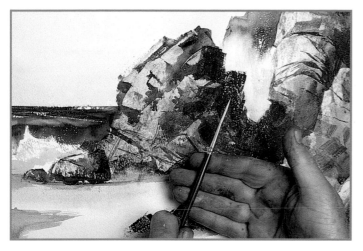

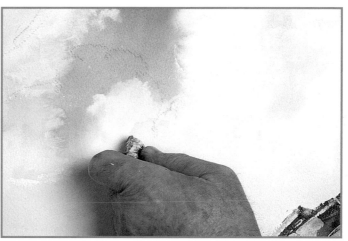

27. Spatter process white, by tapping a loaded brush against your other hand, to create heavier spots of spray between the rocks.

28. Use a putty eraser to remove the original pencil marks in the sky.

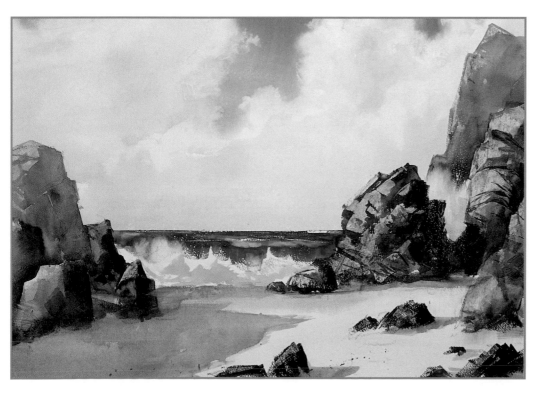

The finished painting.

At the end of step 28, I stood back to look at the whole composition and decided to spatter a few pebbles on the beach.

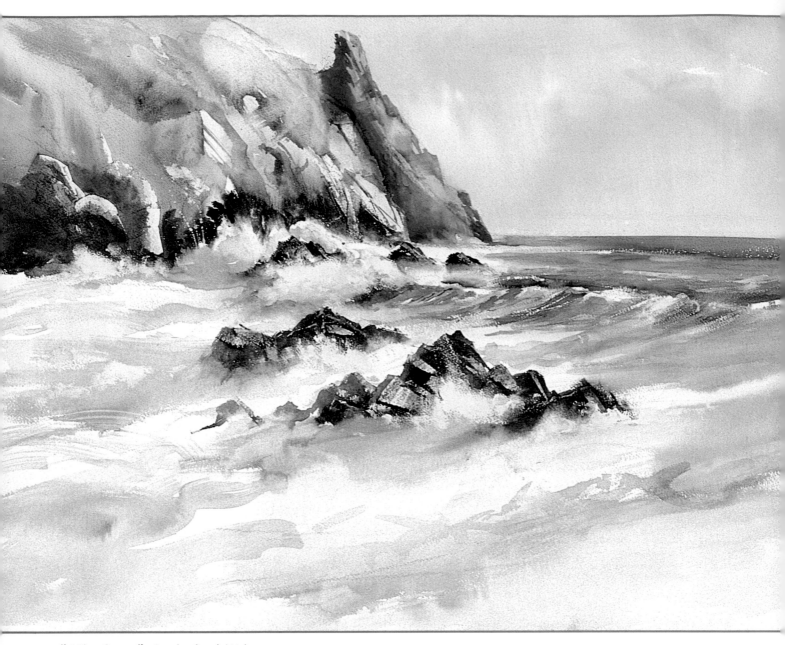

Pobbles, Gower Peninsula, South Wales
Size: 735 x 535mm (29 x 21in)

The diagonal directions of the shapes of the rocks and waves combine to
give a feeling of movement in this composition. Added interest is achieved
by giving these shapes a mixture of soft and rough edges.

Top right
Beach, West Wales
Size: 710 x 510mm (28 x 20in)

I included clouds in this rather large sky area to create some
more interesting shapes and to enhance the windy feeling of this scene.

Bottom right
Walking on Reflections
Size: 710 x 460mm (28 x 18in)

Although it is generally bad practice to have the horizon half way up the
painting, in this instance, I felt that the lower horizontal edge, where
the sea meets the sand, overrides it. The water lying on the wet sand
causes powerful reflections and gives the impression that the figures
are walking on water.

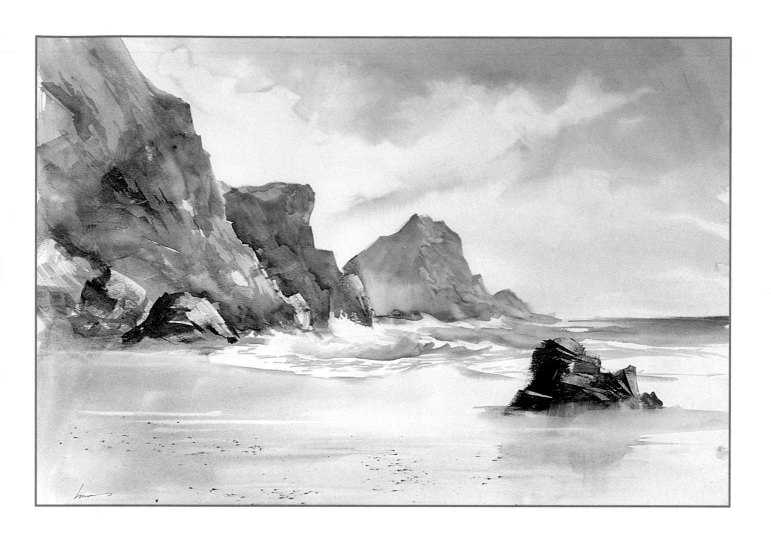

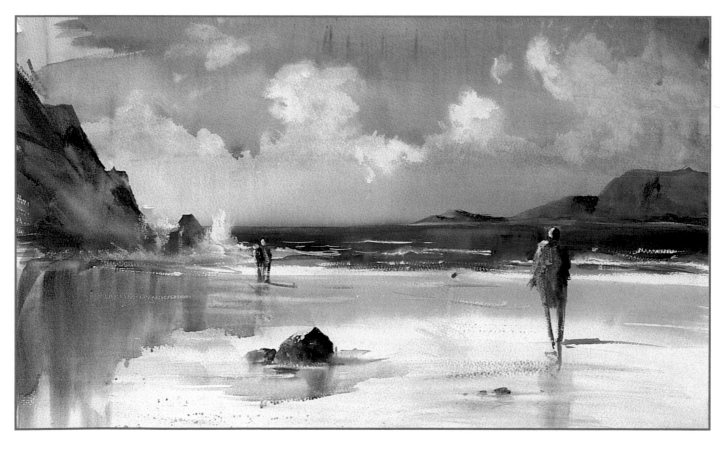

Buildings and figures

The eyeline in this composition is roughly level with the heads of the two people in the far distance. Notice how the lines of the roofs and walls of the buildings on both the left- and extreme right-hand sides appear to vanish to a point on this line. In contrast, the far end of the road appears to vanish to a point above the eyeline giving it an uphill slant. The other two figures lower down the hill are drawn slightly larger to help create this effect.

I felt it was important to have a relatively dark tone both in the sky and in the foreground shadows to help the eye move through the scene to the lighter areas of the buildings. The church in the distance is entirely from my imagination, as are the trees on the left-hand side. Both have been introduced to form a counterchange (light against dark) and to help highlight the buildings.

The chimneys, windows and doors have been unevenly spaced to make the buildings more interesting, and I have used cast shadows to break up the flat surfaces of the walls into interesting shapes of light and tone.

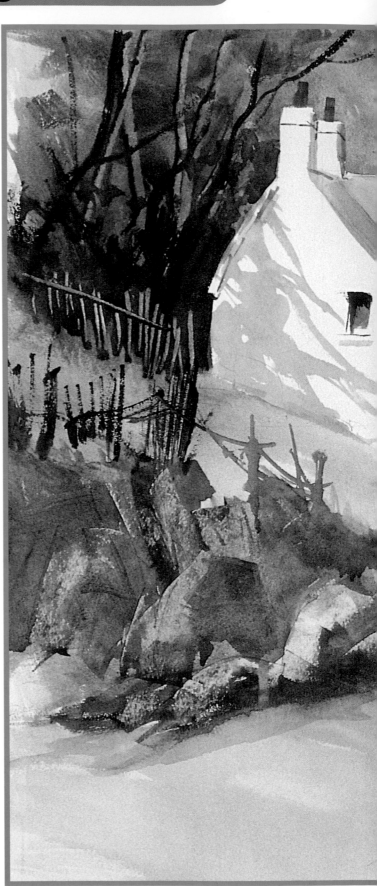

The tonal sketch into which I added the distant church and the group of trees on the left-hand side.

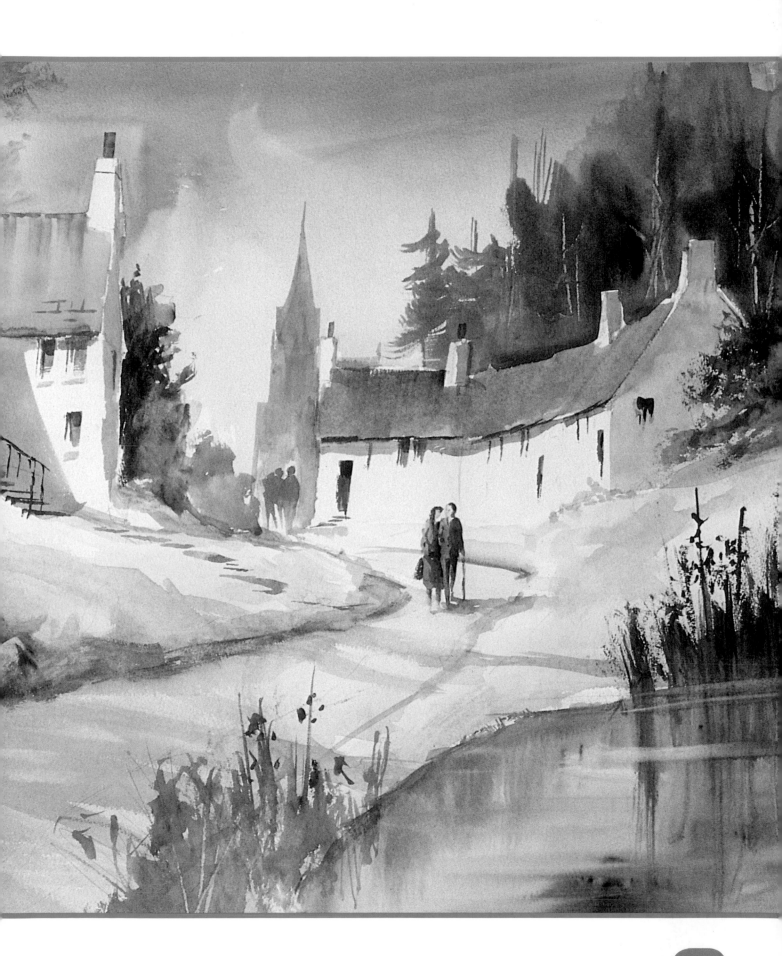

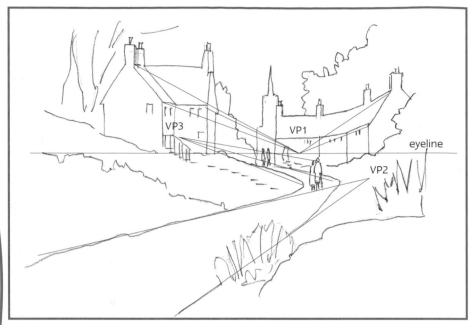

You will need

300gsm (140lb) woodfree, archival paper with a NOT (cold pressed) surface finish
4B pencil
25mm (1in) flat brush
13mm (½in) scraper brush
no. 3 rigger brush
no. 8 round brush
Razor blade
Putty eraser
Colours

aureolin | ultramarine blue | permanent rose

raw sienna | Winsor blue | burnt sienna

cadmium scarlet | lemon yellow

cadmium yellow | burnt umber

1. Using the tonal sketch on page 76 as a guide, make a pencil sketch of the composition. Use a ruler to draw in a true horizontal line at the eye level, then check the angles of your perspective. The buildings on the extreme left- and right-hand sides directly face each other, so their roof lines should converge to the same vanishing point (VP1). Note that the road first goes slightly downhill, so its first vanishing point, VP2, is below eye level. The road then turns and goes uphill and its sides then converge to vanishing point VP3 which is above the eye level. Note also that the heads of both groups of people walking on this stretch of road are also on a line from this vanishing point.

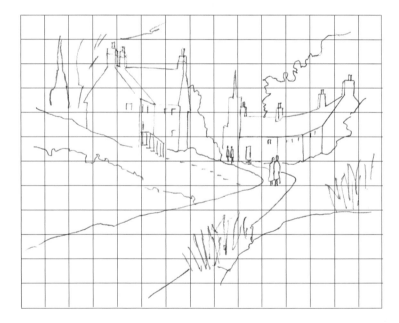

2. Amend the angles of the building as necessary, then draw a squared grid onto the revised sketch.

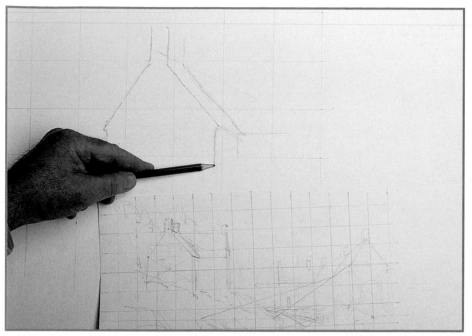

3. Using the grid on the pencil sketch as a reference, transfer the composition onto a scaled-up grid on the watercolour paper.

4. When the sketch is complete, use the putty eraser to rub out the grid lines on the paper.

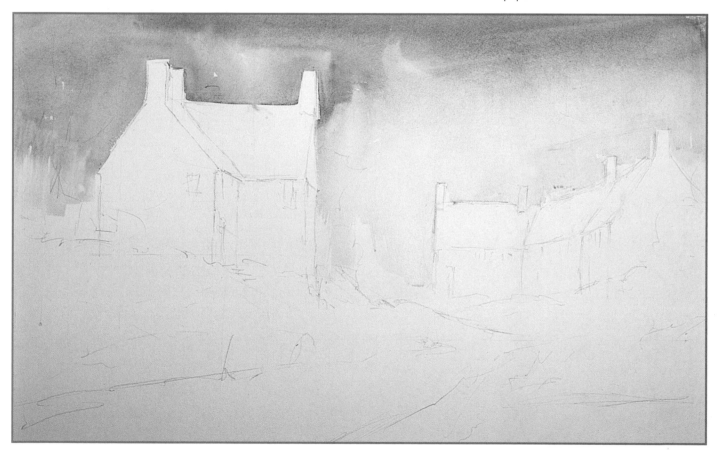

5. Wet the sky area with clean water. Make a wash of ultramarine blue mixed with a touch of cadmium scarlet, then use the 25mm (1in) flat brush to block in the sky, using the edge of the brush to cut round the outlines of the roofs and chimneys. Add a touch of raw sienna at the low, right-hand side of the sky.

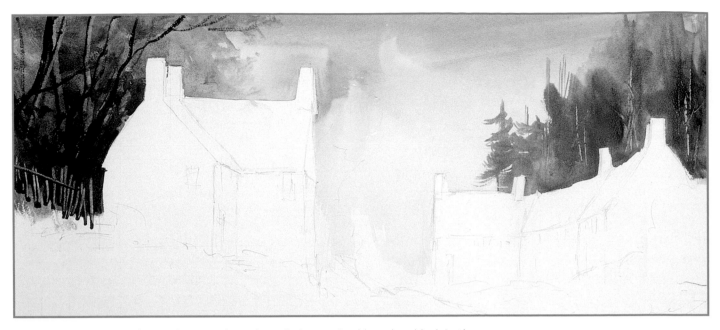

6. Mix some greens with raw sienna and touches of ultramarine blue, then block in the trees. Add touches of permanent rose and more ultramarine blue to build up shape. Add touches of Winsor blue and burnt sienna to build up a multicoloured background. Use the handle of the scraper brush to create tree trunks and large branches. Use the rigger brush and a dark mix of ultramarine blue and burnt sienna to draw finer branches. Finally scrape in an indication of a fence on the left-hand side. Leave to dry.

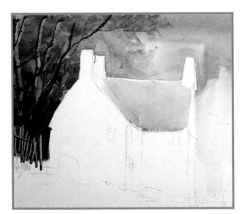

7. Use aureolin to block in the roof of the left-hand building.

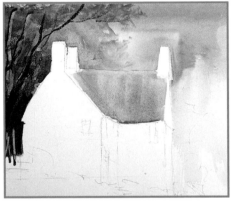

8. While the paint is still wet, mingle touches of cadmium scarlet into the yellow roof.

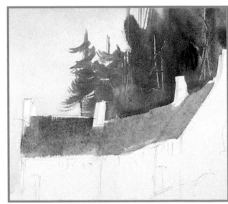

9. Use washes of burnt sienna to block in the roofs of the right-hand buildings, then mingle in touches of ultramarine blue.

10. Mix a dark with ultramarine blue with cadmium scarlet, then paint in the gutters and windows.

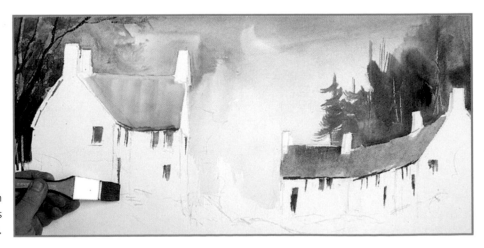

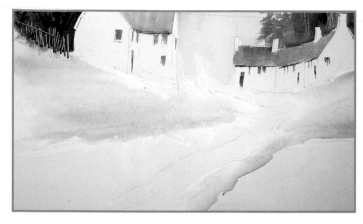 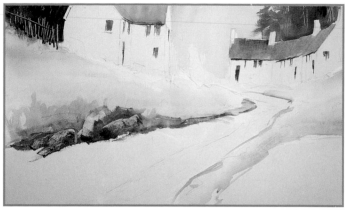

11. Use lemon yellow to block in the grassy bank on both sides of the road. While this is still wet, drop in some ultramarine blue at the top of these shapes and raw sienna along the bottom edges.

12. Use a mix of ultramarine blue and burnt umber to block in some rocks on the far side of the road. Use the razor blade to create surface texture and shape. Weaken the wash, then add indications of foliage behind the rocks. Use the same colour to define the nearside edge of the road.

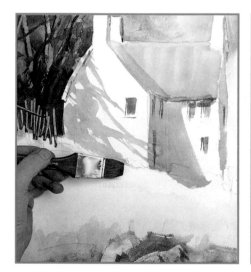 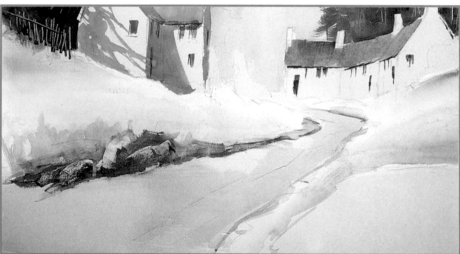

13. Mix ultramarine blue with permanent rose, add a touch of cadmium scarlet to grey the mix slightly, then paint cast shadows on the walls of the left-hand building.

14. Use a weak wash of ultramarine blue to block in the surface of the road. Add touches of cadmium scarlet in the foreground.

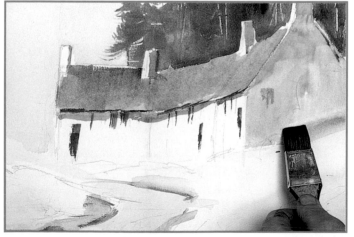

15. Mix a grey with ultramarine blue, permanent rose and cadmium scarlet and, separately, an orange with cadmium yellow and a touch of cadmium scarlet. Use the grey mix to add shadows to the other buildings, then drop a splash of the orange into the end wall. Allow the colours to blend together.

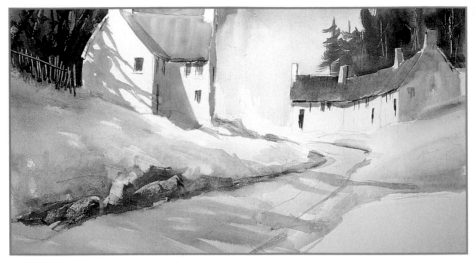

16. Use various tones of the shadow mix, to block in the cast shadows down the left-hand grassy bank, across the road and up the grassy bank at the right. Dry the brush, then lift out speckles of sunlight in the cast shadows.

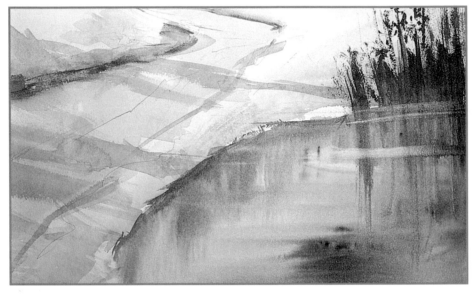

17. Wet the pond, then, using tones of the colours behind the pond, block in the surface of the water; use vertical strokes to create reflections, then finish with a few horizontal strokes to create ripples. Mix a dark with burnt sienna and ultramarine blue, then paint the reeds at the back of the pond.

18. Mix Winsor blue and burnt sienna, then use this colour to break up the large shape of the left-hand grassy bank by adding a steep rocky area. Use the razor blade to create shape and texture, then add darker tones. Use the rigger brush to create an old fence.

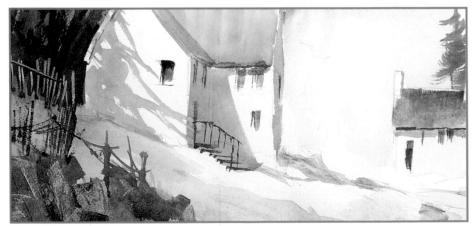

19. Use the edge of the flat brush to add a set of steps and a handrail in front of the left-hand building, and to darken the top part of the window in the end wall.

20. Use a soft pencil to draw two figures in the middle distance and two more further up the road. Remember to scale these figures to the buildings.

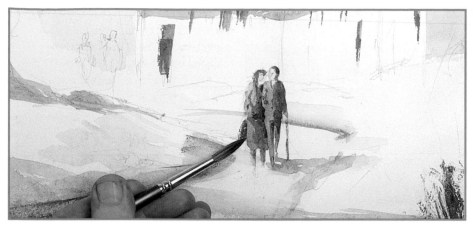

21. Use the round brush and cadmium scarlet mixed with raw sienna to block in the faces of the near figures. Use mixes of burnt sienna and ultramarine blue for the man's coat and ultramarine blue and cadmium scarlet for his trousers. Use permanent rose to indicate the lady's dress. Darken the colours, then add hair, shadowed parts of the clothing and cast shadows on the ground.

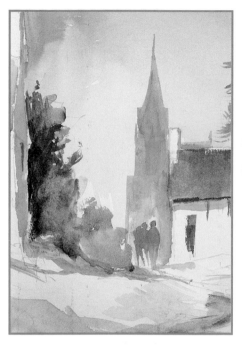

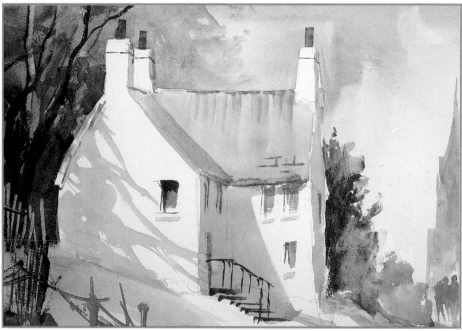

22. Use a pale mix of ultramarine blue with a touch of burnt umber to block in the two distant figures (these do not need the detail given to the foreground figures). Dry the paper, then use the same mix to block in a church tower, weakening the colour as you work down behind the figures. Mix a dark with burnt umber and Winsor blue, then use a flat brush to add trees behind the left-hand house to link the two sides of the painting.

23. Use cadmium scarlet with a touch of Winsor blue to add details to the ridge tiles and an indication of tiles on the roofs. Mix burnt sienna and ultramarine blue, then add the chimney pots and a thin shadow round the chimneys. Weaken the mix, then add the shadows cast by the window sills.

The finished painting.

Having stood back for a look after step 23, I decided to add a few details: some spiky grasses in the foreground; more shape on the right-hand grassy bank; a few steps in front of the door of the right-hand building; and an indication of a path leading up to the left-hand building.

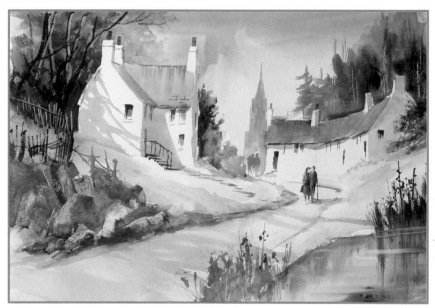

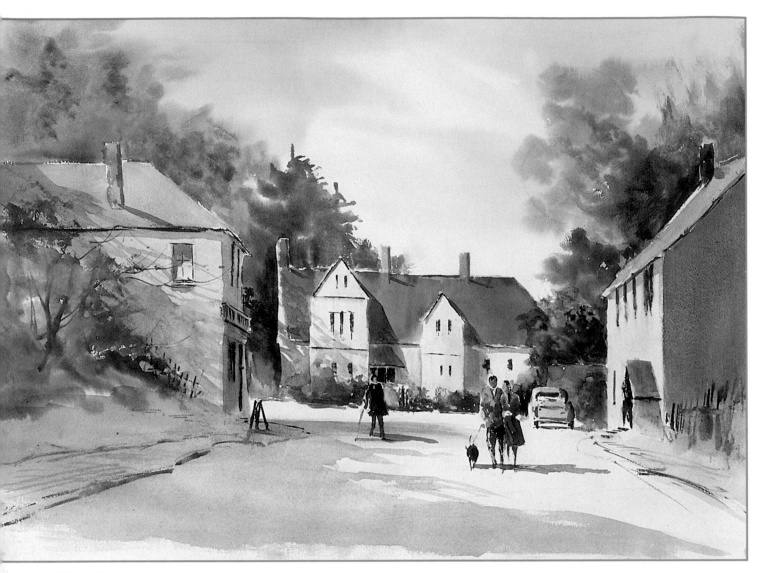

Wylie, Wiltshire

Size: 710 x 510mm (28 x 20in)

In this composition, the perspective lines of the road and the sloping roofs at either side lead the eye to the central figures. Figures give a more lived-in feeling to a painting, bringing it to life. They also provide scale to the composition, enabling the viewer to size the overall scene. Figures in the landscape do not have to be detailed portraits; a few simple strokes are usually sufficient for the marks to be identified as people.

Urchfont Village, Wiltshire

Size: 635 x 430mm (25 x 17in)

I painted this picture in situ at a painting demonstration in the village of Urchfont. It may seem unusual to include the scaffolding, but I felt that the shapes and shadows it created were too attractive too leave out. I added the two figures to bring life to the painting.

Snowscene

When painting snowscenes, it is so easy to fall into the trap of working everything in cool colours. You may have reproduced a scene perfectly correctly, but no one will buy it because it will look too sombre! So, make sure you introduce some warm colours to counterbalance the cools. You do not need much as you can see in this composition. Here I used warm colours to paint the middle-distant cottages, and force the eye to this focal point.

The shape of the road also helps lead the eye to the focal point and it creates depth in the painting as do the soft edges of the background shapes. By contrast, the bold, sparkled edges in the foreground add a crispness to the painting.

A blanket of snow across a landscape means that there are lots of 'white' areas in paintings of snowscenes. Use shadows wisely to break up these areas into light and dark shapes. The shadows also help to show the contours of the ground and the depth of snow on the hedges. The gate in the hedge is placed to allow a nice shaft of light to break up the shadow area.

This painting includes falling snow which has the effect of lightening the other tones in a painting. Bearing this in mind, I painted it with slightly darker tones than I would have done without the falling snow.

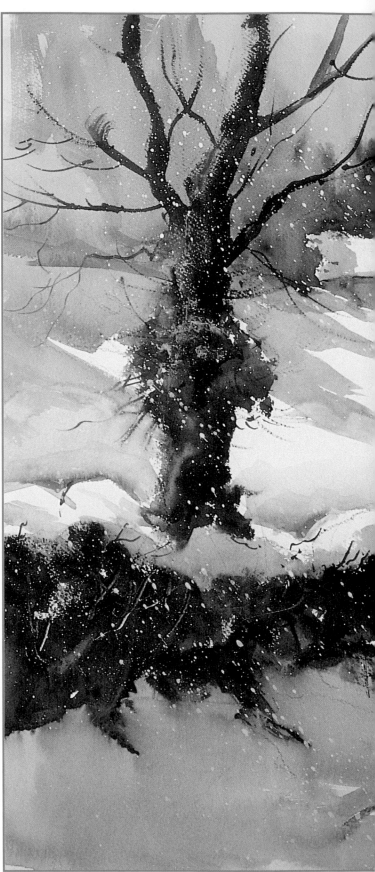

The original pencil sketch used to compose this painting.

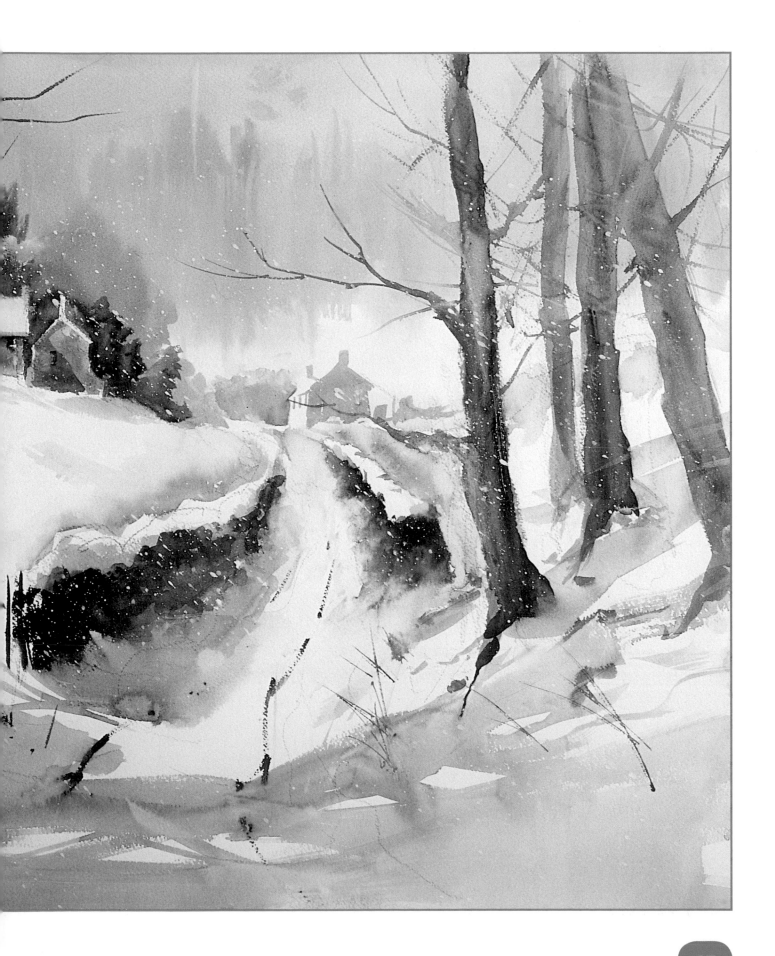

You will need

300gsm (140lb) wood-free, archival paper with a NOT (cold pressed) surface finish

Graphite stick

25mm (1in) flat brush

no. 3 rigger brush

Bristle brush

Razor blade

Process white

Colours

ultramarine blue	permanent rose	burnt umber

burnt sienna	cadmium scarlet	Winsor blue	cobalt blue

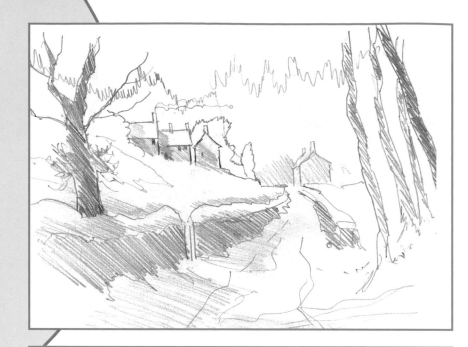

1. Use the graphite stick to sketch in the outlines of the composition onto the watercolour paper.

2. Use the flat brush to wet the sky area. Mix a wash of Winsor blue, then lay this into the sky.

3. Working wet in wet, lay in a wash of permanent rose and allow the colours to blend. Darken the top left-hand side of the sky with more blue.

MOPPING UP
Use a clean, damp sponge to mop up any dribbles of colour.

4. Mix Winsor blue and burnt umber, then drop tones of this mix into the damp sky. Pull the colour downwards to indicate the trees in the far distance.

5. Mix deeper tones with the same colours, then, cutting round the shape of the buildings, paint in the closer stand of trees.

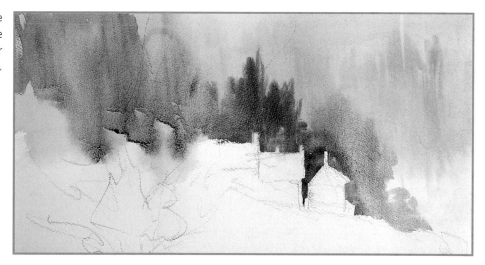

6. Add touches of burnt sienna to the damp greens to add a warm area at the left of the buildings.

7. Use burnt sienna to block in the chimneys and walls of the left-hand group of buildings, then mingle touches of permanent rose and cadmium scarlet. Add burnt umber to the mix, then block in the end wall of the right-hand building.

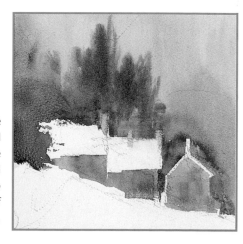

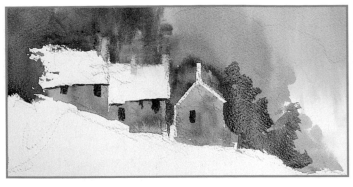

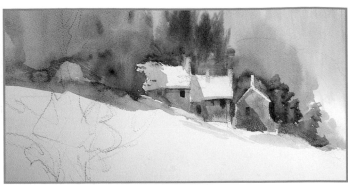

8. Use the scraper brush and a mix of ultramarine blue and burnt umber to add windows, doors and gutters. Use the same colour to reshape the right-hand building and to add a few bushes.

9. Mix cobalt blue and permanent rose with a touch of cadmium scarlet, then lay in cast shadows on the roofs and walls, and on the sloping area in front of the buildings. Note how the roof shadows indicate the depth of snow.

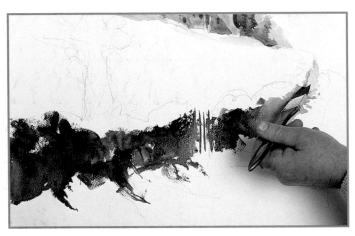

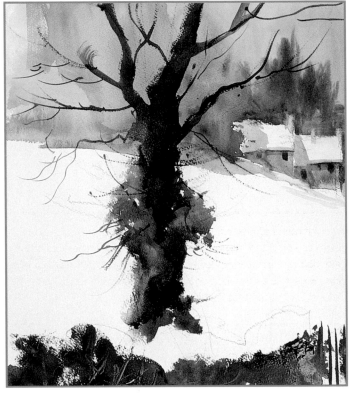

10. Use mixes of burnt sienna and ultramarine blue to block in the foreground hedge and fence, making the colours cooler and less dense as you work to the far end. Hold the brush flat to add sparkle along the top of the hedge.

11. Using the same colours as in step 10, mix browns, greens and darks, then use the flat brush to paint the trunk and main branches of the tree. Change to the rigger brush and add small branches and twigs.

12. Mix a dark with ultramarine blue and burnt umber, then use a rigger brush to accent the shape of the road.

REMOVING MARKS

If you accidentally make an unwanted brush stroke, cut a hole in a piece of scrap paper, place it over the offending mark and use a sponge to remove the mark.

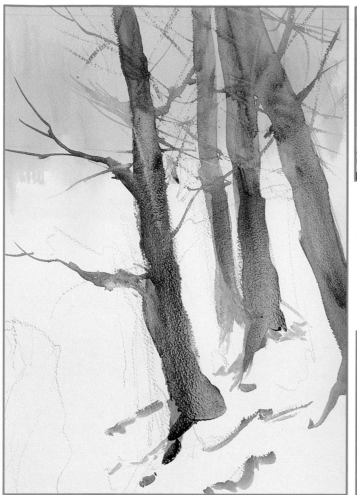

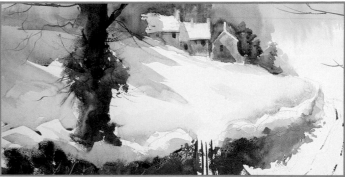

14. Mix up a good quantity of the shadow wash – cobalt blue with permanent rose and cadmium scarlet – then lay in more shadows across the sloping bank at the left-hand side. Add shadows on top of the hedge to indicate the depth of snow and more behind the top of this snow to indicate a deep slope behind the hedge. Soften the top edges of all the shadows with water.

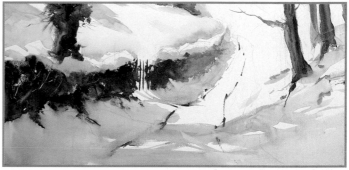

13. Use mixes of burnt sienna and ultramarine blue and the flat brush to add tree trunks at the right-hand side of the road and a few indications of roots. Use the rigger brush to add finer branches and twigs. Use a dry brush and a criss-cross action to add twigs in the sky behind the tree trunks.

15. Use the same shadow mix to add shade at the bottom of the hedge and cast shadows across the road and up the right-hand bank.

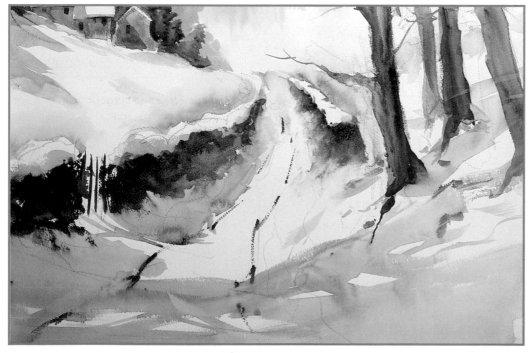

16. Use burnt sienna and ultramarine blue to lay in a hedge at the right-hand side of the road. Use the shadow wash, mixed in step 14, to add more shadows behind the trees. Balance these with deeper tones on the distant part of the left-hand hedge.

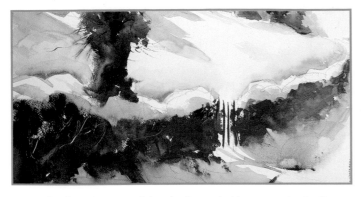

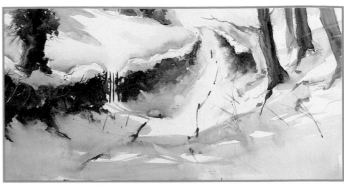

17. Make deeper tones of the shadow mix, then accentuate the shadows behind the top of the snow on the hedge at the left-hand side.

18. Mix burnt sienna with a touch of ultramarine blue, then use the rigger brush to flick in an indication of a few grasses and twigs on either side of the road.

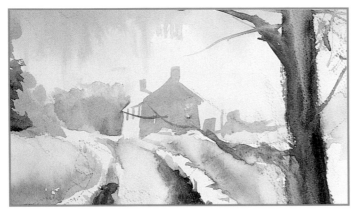

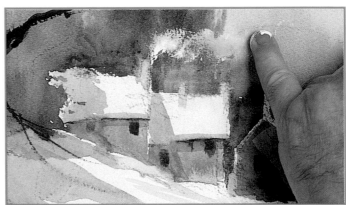

19. Mix a weak wash of ultramarine blue with a touch of burnt umber, then block in the distant building and some shadowy shapes at the right-hand side. Accentuate the sunlit side of the building (which is bare paper) by painting in an indication of trees in the distance.

20. Apply process white with a finger to indicate smoke from the chimney.

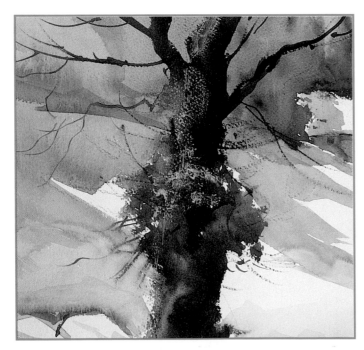

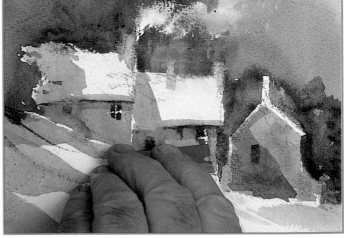

22. Use the corner of a razor blade to scratch out details on the windows.

21. Use mixes of Winsor blue and burnt umber for the ivy on the tree. Hold the brush flat to produce sparkled edges.

The painting, at the end of step 22. You could stop painting at this point, but I wanted to show you how I add falling snow. Adding snow has the effect of lightening the tones in a painting, so, knowing this before starting this demonstration, I made them slightly darker than I would otherwise have done.

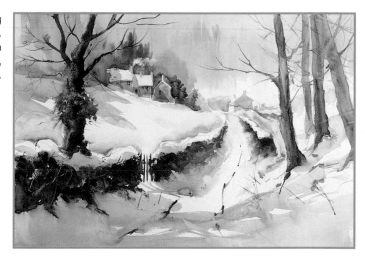

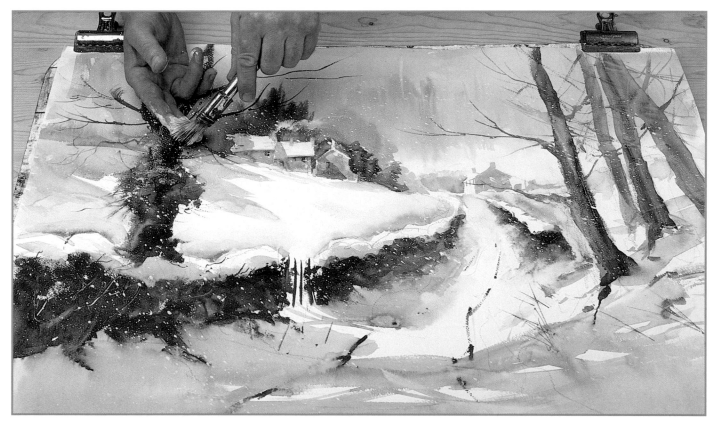

23. Load the bristle brush with process white and drag it across your fingers to flick specks of falling snow over the painting. Angle the brush to indicate the direction of the wind driving the snow.

The finished painting.

The direction in which you apply the snow determines the wind conditions. For this painting, I applied the snow diagonally across the paper to imply a degree of windiness. Applying it vertically would have produced a still, peaceful and less dynamic effect. For this large painting, which measures 735 x 530mm (29 x 21in), I used a large brush to produce a variety of sizes of snowflake to give added perspective. For smaller paintings you could use an old toothbrush.

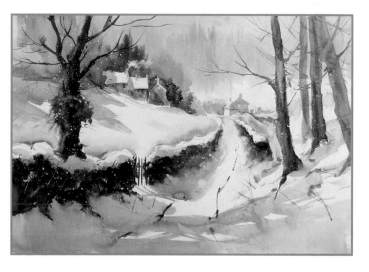

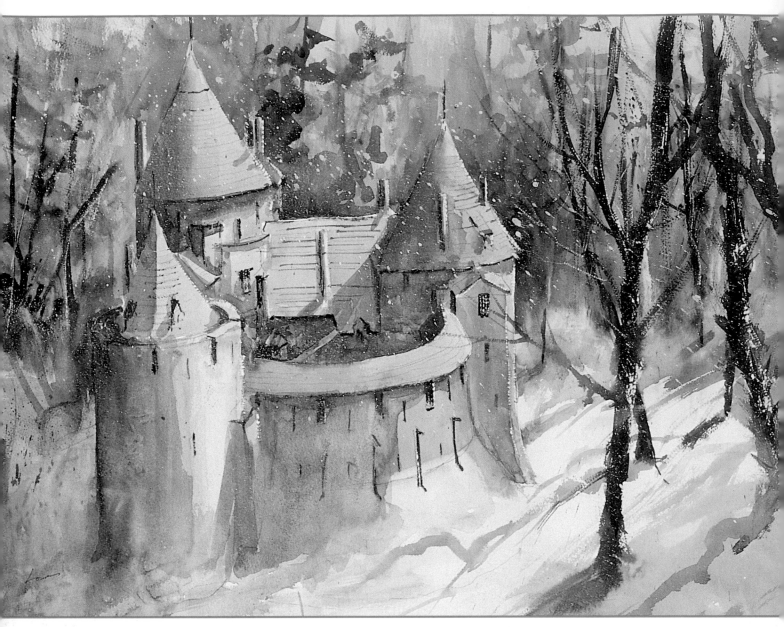

Castell Coch, near Cardiff, Wales
Size: 735 x 510mm (29 x 20in)

This castle was rebuilt by the Marquis of Bute approximately one hundred years ago. The décor inside is magical with murals of Aesop's fables. It has been used as a film set many times for films such as 'The Black Knight' and 'The Prisoner of Zenda'. The surrounding trees make it almost impossible to find an interesting view of the castle, but I was lucky to discover a detailed model of it in one of the rooms inside. This allowed me to photograph it from lots of different angles, and this unusual aerial view is taken from one of these photographs.

Winter Lakeland

Size: 735 x 510mm (29 x 20in)

In this imaginary composition, it was important to get the tones of the distant mountains correct. Their sunlit sides are lighter than the sky, while those in shadow are darker. The use of soft edges pushes them back into the distance. All the shapes used in this painting – those of the river, the stands of trees and the mountains – were designed to lead the eye to the house.

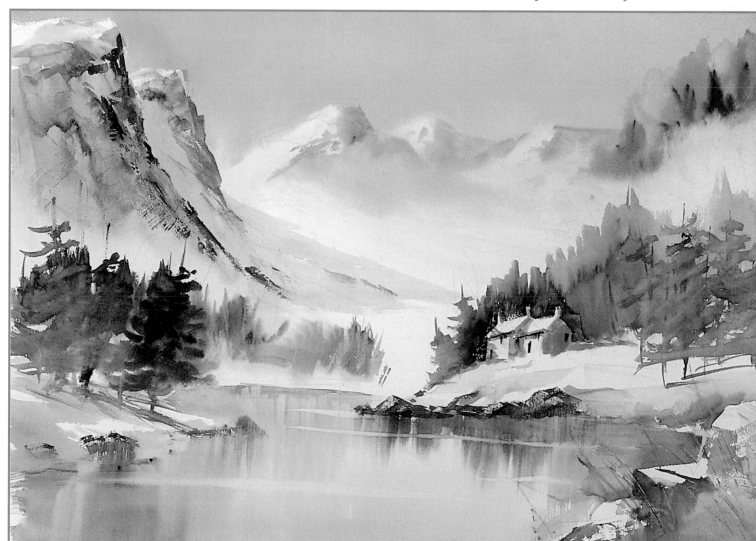

INDEX

Gathering Storm at Yerwol
Size: 735 x 535mm (29 x 21in)

This was painted on 640gsm (300lb) rough paper in order to give added texture. I started by painting in the background colours of the sky which I left to dry. I then carefully re-wetted the sky, painted in the clouds, then used a water sprayer to create the rain, as explained on page 25.